MICHIGAN
Literary Luminaries

MICHIGAN
Literary Luminaries

From Elmore Leonard to Robert Hayden

Anna Clark

THE
History
PRESS

Published by The History Press
Charleston, SC 29403
www.historypress.net

Front cover, bottom: Courtesy Bethany Helzer; top, left to right: Robert Hayden (*left*). *Burton Historical Collection at the Detroit Public Library*; Ernest Hemingway. *Ernest Hemingway Collection, John F. Kennedy Presidential Library and Museum, Boston*; Dudley Randall. *Courtesy of Melba Joyce Boyd. Back cover, bottom*: Grand Marais. *Courtesy Bethany Helzer; top, left to right*: Detroit downtown. *Courtesy Geoff George*; Elmore Leonard. *Courtesy of the* Detroit News *archive.*

First published 2015

Manufactured in the United States

ISBN 978.1.62619.937.8

Library of Congress Control Number: 2014956339

Contents

Acknowledgements

Original reporting and writing that I did for the *Detroit Free Press*, the *Chicago Tribune*, *Creative Exchange*, *Model D*, *Publishing Perspectives*, the *Daily Beast* and *Next City* is revived for significant portions of this book. I am grateful to each of these news outlets for their support of literary journalism. I also relied a great deal on articles, biographies, histories, research and literary essays published by a number of others. For the sake of simplicity and fluency, there are no footnotes in the text acknowledging each specific citation, but please see the source listing at the back of the book for full credits.

Thank you to Dan Austin for hammering this manuscript into shape, and thank you to Greg Dumais and Darcy Mahan for shepherding it into life. Thank you to Megan Snow, Geoff George, Bethany Helzer, Nick Hagan, Kevin Robishaw, Geoffrey Berliner and J. Gordon Rodwan for sharing their photography talents with this book. And thank you, always, to my friends and family for their kindness, insight and laughter.

Preface

I've written a number of stories about the Michigan country—the country is always true—what happens in the stories is fiction.
—Ernest Hemingway

Kalamazoo is a midsize city, but in literary terms, it is gigantic. The southwest Michigan hub, which sits halfway between Chicago and Detroit, has quietly become a thriving book town, cultivating both extraordinary writers and national attention.

"You can't throw a rock without hitting a poet," Bonnie Jo Campbell told me when I interviewed her for the *Detroit Free Press* in 2014. She is one of the most celebrated writers in Kalamazoo's literary scene, an author who grew up in the area, moved away for a time and then returned. In her fiction, Campbell fixates on the rural landscape of southwest Michigan. She fuses the sacred and the profane in tales that have a trace of myth about them. The militiamen, the dreamers, the hunters, the underemployed custodians, the farmers, the lonely-hearted bigots, the lovers of wilderness and gardens and animals, the protective parents, the meth addicts, the young teens with old souls—she tells stories about them that shake in the bones. One reads feeling as if we, like her characters, are on the edge—a way of life ended or begun, the ground quaking beneath our feet. *Once Upon a River*, Campbell's 2011 novel, was described by the *Washington Post* as "fresh and weathered at the same time…rugged tales as perilous as they are alluring." Her 2009 short story collection, *American Salvage*, a finalist for both the National Book

Award and the National Book Critics Circle Award, hooks into an under-chronicled corner of the country where money is tight, odds are long and hearts are full.

Though Kalamazoo's writers are diverse enough to defy generalizations, its standout literature fuses lyrical intensity with powerful stories. Besides Campbell's books, there is David Small's *Stitches*, an illustrated memoir full of menacing silences and rich vulnerability. It is another National Book Award finalist. Stuart Dybek, a stalwart of the writing program at Western Michigan University (WMU), authored the story collections *Coast of Chicago* and *I Sailed with Magellan*, both of which find the surreal in the grittiness of urban landscapes. And Diane Seuss writes free-verse poetry that is wound tight with kinetic imagery: "The grief, when I finally contacted it / decades later, was black, tarry, hot, / like the yarrow-edged side roads / we walked barefoot in the summer."

"I found something magical here: I could write," said Campbell, who studied writing at WMU under 2010 National Book Award winner Jaimy Gordon, author of *Lord of Misrule*. "I tried to write in Boston, Milwaukee… But I need to write about the kind of people I can understand. I'm among my tribe [in southwest Michigan]." Poet Elizabeth Kerlikowske described to me the literary culture of Kalamazoo as "alive, thriving, morphing, and both deep and rich." Kerlikowske is the longtime president of Friends of Poetry, a community group with the mission to "enhance the enjoyment of the reading and writing of poetry."

Kalamazoo College and especially WMU have strong creative writing programs that anchor the city's literary culture. WMU was first in the state to offer a master of fine arts degree in creative writing and is one of the few universities nationally to offer a PhD in the craft. That alone draws talented writers to Kalamazoo from around the country. *Third Coast*, an acclaimed literary journal, is published out of WMU. The university also hosts a book publisher called New Issues Press and a reading series that brings national talent to the city, as well as a summer writing program in Prague.

Laurie Ann Cedilnik was one of the young writers drawn to Kalamazoo for WMU's PhD program in literature and creative writing. She is the editor-in-chief of *Third Coast*. "I'm originally from New York City, and I puzzled many of my hometown friends with my choice to move to such a small town. But I find Kalamazoo an ideal place to live and write," Cedilnik said in an e-mail interview. "I've gotten more writing done here than I ever have in my academic career," she said, citing the city's relaxed atmosphere, enlivening cultural opportunities and affordable cost of living.

Thisbe Nissen, a fiction writer who teaches at WMU, moved to Kalamazoo from New York's Hudson Valley after having once traveled out of her way to visit the town just because she was a fan of Dybek. (Though Dybek now lives elsewhere, he returns to WMU to teach master classes.) As Nissen puts it, the isolating work of being a writer takes on a social atmosphere in Kalamazoo, where the grad students who run *Third Coast* have parties to read submissions and people in the neighborhoods around campus host poetry and fiction readings in their homes. "That to me says something about the atmosphere," Nissen told me. "Somebody has a party, and it's not to play cornhole but to hear poets in the living room."

Students and faculty in the writing programs form the core of Kalamazoo's literary community, but they are not the sum of it. The city is also home to the Kalamazoo Poetry Festival, which takes place each April. The Kalamazoo Book Arts Center runs the Poets in Print series and hosts the high-spirited Edible Book Festival. At least three independent bookstores carry a great deal of fiction and poetry and regularly bring in writers and readers for book events. For nearly forty years, Friends of Poetry (FOP) has made literature a tangible presence in the city by turning poems into murals around downtown. It annually teams up with the Kalamazoo Valley Museum to run Artifactory, where community members submit poems that are used by a curator as a way to discuss history. FOP also launched a reading series in partnership with the Kalamazoo Public Library, a beloved institution that was named National Library of the Year in 2002. Other leading collaborators in the community include businesses like Bell's Brewery, which partnered with New Issues Press to publish an anthology of Michigan poetry, and Louie's Trophy House Grill, which holds a monthly Poetry Night hosted by *Third Coast.*

"People who have been anchors in the community are writers first, and then really good teachers and then good promoters of writing," said Kalamazoo College's Andy Mozina, author of *The Women Were Leaving the Men* and *Quality Snacks.*

⸻

Is there something in the water that makes Kalamazoo such a tremendous literary community? Campbell wonders if there might be. The city's history makes for an unusually inspirational landscape. Its industrial past is tied to the South—millions of southerners moved north for jobs throughout the twentieth century during the Great Migration, transforming neighborhoods,

businesses and schools. Literary artists, too, were influenced by the changing culture. Campbell sees parallels between Michigan writing and southern writing, particularly in the way writers "treat our eccentrics" and their intimate engagement with the natural world. "We all have a bit of survivalist in us, the sense that if it all collapses, I could get by," she said.

Like other communities in Michigan, Kalamazoo has experienced more than its share of economic precariousness. Campbell wonders whether "the very things that create and exacerbate economic stress are related to the things that create great art." People who must figure out how to get by, who have learned hard lessons about instability, develop the questioning spirit and wonderment that is necessary for writing literature. At the same time, Kalamazoo's industrial history has scrubbed it of shine and gloss, meaning that those who live there have no illusions. "The people that choose to be here are devoted," Campbell said. "Nobody is on a high horse about anything. It's humbling. [There's the lingering idea that] maybe we could do better for ourselves…It keeps us thinking. It keeps us considering the other side."

Several years after arriving in Kalamazoo, Nissen is sold. "I grew up in New York [City], a place I don't like very much at all," she said. "I'm so glad to be in a place [now] where the things I overhear people talking about in restaurants and in line at the grocery store are things I want to write about."

Michigan is full of these stories. From tiny towns necklacing the Great Lakes to towering old cities, the landscape of the two peninsulas has stirred more than a century of the nation's greatest writers. Jeffrey Eugenides, a Detroit native who grew up in Grosse Pointe, is one of them. In *Middlesex*, his Oprah-approved, Pulitzer-winning novel, he follows Cal, an intersex narrator of Greek descent who grows up in Detroit in the 1960s and '70s. *Middlesex* is a sprawling and exuberant multigenerational saga that explores gender identity alongside explosive race and ethnic dynamics. A busy novel that draws from Greek mythology, *Middlesex* also finds Cal's grandmother working for the Nation of Islam, which was founded in Detroit, and Cal in a relationship with someone called Obscure Object, which references the film *That Obscure Object of Desire*. Like Cal, this is a novel that refuses to be pigeonholed. It is neither this nor that.

There is also poet and novelist Laura Kasischke of Chelsea, Michigan. She grew up in Grand Rapids and practically swept the Hopwood writing

awards as a University of Michigan student; later, she won a National Book Critics Circle Award for poetry. Among Kasischke's many books is *Eden Springs*, which brings an imaginative spin to one of the strangest of true Michigan stories. In the early twentieth century, a utopian community called the House of David chose the lush land of Benton Harbor to build a village and await an eternal life lived not in the spirit but in the flesh. The community was trademarked by its famed amusement park, semipro baseball team, uncut hair, white clothing and handsome, charismatic founder. Kasischke's story situates itself in the spring of 1923, shortly before scandal breaks at the House of David. Built like a collage—photos, legal documents, court testimony and news clippings sit aside fictional vignettes—*Eden Springs* manages to evoke both suspense and prophecy.

And then there is Ben King, a popular poet born in 1857 in St. Joseph, my own hometown on the Lake Michigan shore. "He existed as the welcome and mirthful shadow of conventional and tiresome things," wrote John McGovern of the Chicago Press Club in the introduction to an 1894 collection of King's verse. Admired for his abilities as a satirist, often set to theatrical piano playing, he was a favorite performer at church fairs, banquets and Elks Club socials. He also wrote sentimental lyrics published in newspapers, which brimmed with love for the "old River St. Joe," which flows into Lake Michigan. "How oft on its banks I have sunk in a dream. / Where the willows bent over me kissing the stream." But just as his star was rising, while on a performance tour, he was found dead in a hotel room in Bowling Green, Kentucky. Only the night before, he had been carried out of the theater on the shoulders of an adoring audience. He was not yet forty years old, and it was not clear what caused his death. "But when Ben King died, St. Joseph became more widely known in one day than hundreds of excursions and a thousand orchards had served to advertise it in the past," wrote humorist Opie Read in *Ben King's Verse*. It was Read, who had been on tour with King, who found him in the hotel room. King was so beloved that thirty years after his death, community leaders raised money for a bronze bust of him, set upon a granite base carved with lines from his poetry. Today, the bust stands in St. Joseph's Lake Bluff Park, among dozens of monuments to soldiers and firefighters. It is a rare tangible testament to how a community once cherished an artist as a hero.

This is a book for the storytellers. With equal parts reportage, literary criticism and history, *Michigan Literary Luminaries* was created as a labor of love. It is best understood as a collection of linked essays, a peek into the wealth of contemporary and classic literature that is unified by its

sense of place in the North Country. It is by no means comprehensive, nor is it a ranking of the state's "best" writers. Michigan has more than its share of literary talent, and there are ten thousand storytellers whom I regret not including here. Chris Van Allsburg, Pearl Cleage, Jamaal May, francine j. harris, Marge Piercy, Vievee Francis, Matthew Olzmann, Terry Blackhawk, Terry McMillan, Christopher Paul Curtis, David Small, Sarah Stewart, Naomi Long Madgett, Toi Derricotte, Jane Kenyon, Donald Hall, Jim Daniels, Jack Driscoll, Thomas Lynch, Ring Lardner, Dominique Morisseau, Charles Baxter—this is only a handful of others who are worthy of the greatest attention.

It also does not escape my notice that of the writers featured in this book, nearly all are male and white. That certainly is not a reflection of how talent is distributed among Michigan writers—but it does reflect the distorted opportunities over the twentieth century for women and people of color to practice their art. Our challenge is to write a new script for the next hundred years, one where strong public and private systems support a more diverse literary culture. The stories of too many artistic geniuses are left stunted. That diminishes us all.

This book focuses on fiction writers and poets who explored life in Michigan in their work: our feeling for nature, hard work, community, social class and the uncertainty that comes with not having enough and of having too much. From Elmore Leonard to Robert Hayden, their writing is idiosyncratic and ambitious, at once surreal and worldly wise. Their work invigorated the public imagination with intelligence, honesty and grace. By questioning the myth of the American dream, they themselves wrote new myths.

Ernest Hemingway in the North Woods

Living memory of Ernest Hemingway has nearly died out, not only among his old fishing buddies in the richly forested tip of Michigan's mitten but also among his descendants who visit the north woods. It is only now, as firsthand accounts fade, that these little towns have begun to celebrate their connection to the writer, in both life and literature.

Chris Struble is the sort of man who wears a green fleece vest over his collared shirt while working at his downtown Petoskey jewelry store. Struble—middle-aged and bald with a friendly smile—is a jewelry designer and metalsmith who leads Haunted Petoskey tours. He moonlights as the president of the Michigan Hemingway Society, which advocates for a deeper understanding of the author's connection to the state.

As Struble tells it, it was only about ten years ago that Northern Michigan began to embrace Hemingway as part of local culture. Even now, "there's still resistance. It's a weird thing," he said to me. One local library did not even have any of his books until the Hemingway Society intervened. In trying to make sense of this, Struble, a Northern Michigan native, speculates that midwestern politeness might be partly to blame. Holding a lecture on, say, the legacy of mental illness in Hemingway's family would be uncomfortable when his relatives are present. Local personalities on whom the author based his characters cannot help but take his stories personally—and not always in a cheerful way. Best to keep quiet, then.

What's more, Struble said, Northern Michigan holds tight to its traditional low-key culture. It is wary of hooking its reputation to a celebrity, even a

literary one. In other words, as he put it, "we do what we do well, and we don't need Hemingway."

But that is changing. Northern Michigan is finding new and thoughtful ways to honor the stories that Hemingway told about the region while in turn telling its own Hemingway stories

As soon as it was safe for the boy to travel, they bore him away to the northern woods. It was a long and complicated journey for a child only seven weeks old.

Ernest Hemingway: A Life Story was the first great biography of the writer, a seven-hundred-page tome by Carlos Baker, a Princeton University professor who spent seven years writing it. The book begins not by highlighting the Nobel laureate's great works, or even his hometown of Oak Park, Illinois. Instead, in the first sentence of the first chapter, Baker places Hemingway in Northern Michigan, the landscape that was the great love of his life.

Hemingway's family lived in a gracious home just outside Chicago, where his father worked as a doctor. But when summer rolled around, they traveled to a cottage just off the shore of Walloon Lake that Clarence "Ed" Hemingway and his wife, Grace, built in 1898. These were the early days of "Up North" tourism, nearly six decades before the building of a bridge to connect Michigan's two peninsulas. Railroad companies had only just extended their lines northward, where large land grants were designed to encourage people to settle there. Railroads, local merchants and steamship companies partnered for a massive tourism campaign that turned out to be persuasive. Once people got a taste for the cool, clean air blowing off the Great Lakes, they kept coming back for it—or decided to stay permanently. In 1873, Petoskey was home to two families, according to local historian and Hemingway scholar Michael R. Federspiel. By 1900, the first full summer that the Hemingways spent at the cottage, Petoskey had about six thousand full-time residents. The city has about the same population today—but in the summer, that number more than quadruples.

While Ed and Grace Hemingway were part of a larger turn-of-the-century movement, they did not spend their summers at the fashionable shoreline resorts popping up in Petoskey and Traverse City. They opted for a tidy little inland cottage, surrounded by forests, farms and settlements of

Ottawa and Ojibwa Indians. They called it Windemere; Grace chose the fanciful name "Windermere" as an echo of the famed English lake, but everyday shorthand soon simplified it. Hardly a modern-day McMansion, it was built for $400, or about $11,000 in today's dollars, and it measured twenty feet by forty feet, with no electricity or plumbing. The family bathed in the lake, just down a sandy road. A small outhouse was situated in a thicket of evergreens on a low hill. The one-story frame structure, built with local lumber, had a porch, a brick fireplace, white pine paneling, oil-lamp lighting, an iron-handled pump for well water and two bedrooms. As the family grew to six children—the fifth child, Carol, was born at Windemere, delivered by Ed himself—the cottage's two cushioned window seats were used as beds. The family later added a kitchen wing, which connected to the house by a screened-in dining area, and a three-bedroom sleeping annex just behind the cottage for the kids. But Hemingway eventually took up the habit of sleeping by himself in a tent pitched outside, near the rail fence.

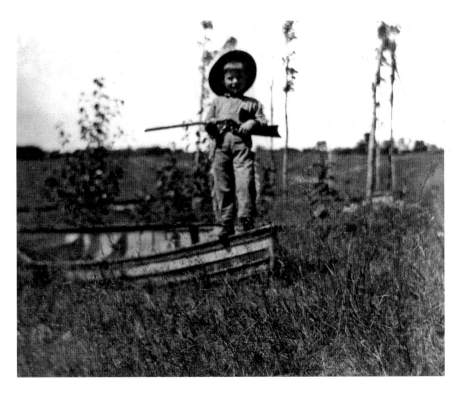

Young Ernest Hemingway on a boat near Windemere Cottage at Walloon Lake, Michigan. Summer 1903. *Ernest Hemingway Collection, John F. Kennedy Presidential Library and Museum, Boston.*

This was the twilight of the timber industry. In the Nick Adams stories that Hemingway later wrote, featuring the character that was his youthful alter ego, the sounds of logging are laced throughout the text. "The End of Something" begins with a description of Horton Bay, two miles from Windemere on Lake Charlevoix. Hemingway persistently referred to it as "Horton's Bay," reflecting his colloquial way of describing the place. For him, it was a name spoken and heard, not read on a map.

> *In the old days Horton's Bay was a lumbering town. No one who lived in it was out of sound of the big saws in the mill by the lake. Then one year there were no more logs to make lumber. The lumber schooners came into the bay and were loaded with the cut of the mill that stood stacked in the yard. All the piles of lumber were carried away. The big mill building had all its machinery that was removable taken out and hoisted on board one of the schooners by the men who had worked in the mill. The schooner moved out of the bay toward the open lake carrying the two great saws, the travelling carriage wheels, belts, and iron piled on a hull-deep load of lumber. Its open hold covered with canvas was lashed tight, the sails of the schooner filled and it moved out into the open lake, carrying with it everything that had made the mill a mill and Horton's Bay a town...*
>
> *Ten years later there was nothing of the mill left except the broken white limestone of its foundations showing through the swampy second growth.*

Hemingway spent the first twenty-two summers of his life in Northern Michigan. He fished for pike, perch, bass and trout, both alone and with friends. He rowed in cool waters, cooked over an open fire and pored over books. His daily chore was to fetch milk from a neighboring farm, padding back up the dirt road as softly as he could, lest he spill. As a young child, he was fond of a large-form monthly serial called *Birds of Nature*; he surprised his mother when he correctly named seventy-three different kinds of birds. His father taught him how to properly handle a gun and how to use an axe to make a woodland shelter out of hemlock boughs. As Baker wrote in his biography, threading in lines from the story "Fathers and Sons":

> *The boy's later memories of his father were nearly always in outdoor settings—flushing jacksnipe on the prairies; walking through dead grass or harvest fields where corn stood in shocks; passing by grist or cider mills or trickling lumber dams. He thought of his father whenever he saw a lake or an open fire or a horse and buggy or a flight of wild geese, or whenever*

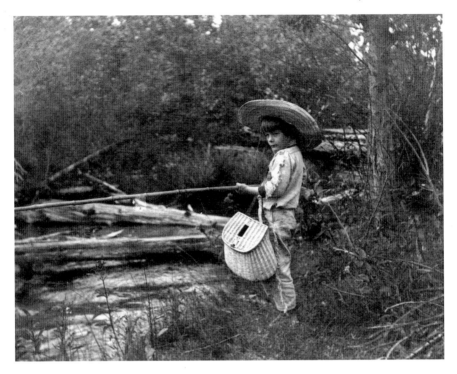

Young Ernest Hemingway fishing in Horton's Creek, near Walloon Lake. July 1904. *Ernest Hemingway Collection, John F. Kennedy Presidential Library and Museum, Boston.*

there was wood to be split or water to be hauled... "He liked to work in the sun on the farm because he did not have to," and loved all forms of manual labor, as Ernest in his maturity did not.

Grace ensured that music, art and theater were constants in the lives of her children. She stacked the bookshelves with British authors, from Shakespeare to Dickens. At Windemere, she tracked the heights of the kids on the frame of the back porch door.

Over in Horton Bay, the Dilworths lived in Pinehurst Cottage. Jim had a blacksmith shop, and Elizabeth—whom Hemingway called Auntie Beth—ran a "chicken-dinner establishment" and country inn. Their son Wesley became Hemingway's friend, though he was seven years older. In the story "Up in Michigan," he refers to the family by name when he describes Horton Bay as "only five houses on the main road between Boyne City and Charlevoix...Smith's house, Stroud's house, Dilworth's house, Horton's house and Van Hoosen's house. The houses were in a

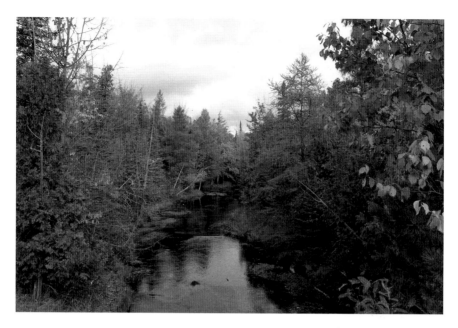

Horton Creek, near Walloon Lake. October 2014. *Anna Clark.*

big grove of elm trees and the road was very sandy. There was farming country and timber each way up the road."

In 1905, the Hemingways bought forty acres across Walloon Lake and called it Longfield Farm. Ed planted fruit trees, while Hemingway scampered through the grass wearing "an Indian suit with fringed leggings." The following year, Hemingway's parents permitted the seven-year-old to bring a neighbor boy, Harold Sampson, on the summer trip. The boys played most often at Longfield. Upon discovering wooden crosstie rails used to haul lumber in open wagons, they hitched rides to Horton Bay to see Wesley, who took them fishing at the creek just west of the general store. Then Auntie Beth fed them crisp fried trout and chicken at Pinehurst.

American Indians lived in the low green hills around Windemere. They picked thick red raspberries and blackberries and sold them to summertime tourists. Hemingway's paternal grandfather rented a shack down by the water to a tall Indian who lived alone, walked through the woods at night and gave Hemingway a canoe paddle made of ash wood. Simon Green, a chubby Indian, lingered outside Dilworth's blacksmith shop and went shooting with the Hemingways. When Hemingway wrote his first story to appear in print—a bloody 1916 tale for his high school

literary magazine—he set it in Northern Michigan. It is about a Cree man named Pierre who suspects his hunting partner has stolen his wallet.

Nick Boulton and Billy Tabeshaw were two Ojibwas who worked as sawyers. Nick's daughter Prudence sometimes worked for Grace. One summer day, Hemingway's father hired Nick and Billy to cut up beech logs that had broken off from a boom in the lake and drifted ashore. Hemingway watched as they chopped with cant hooks and axes, and he listened to their talk. He later reimagined that day in a short story called "The Doctor and the Doctor's Wife." As well, the third short story Hemingway wrote for his school literary magazine was titled "Sepi Jingan," after Billy Tabeshaw's dog. In it, the dog saves Billy from a murderer who ties him to the Pere Marquette railway tracks.

It was not unusual for Hemingway's imagination to zero in on the macabre. The summer he turned fourteen, Harold Sampson again accompanied the family to Windemere. Hemingway's sister Marceline brought her friend Ruth. The four of them stayed up late reading Bram Stoker's *Dracula* beside the fireplace one August night. Haunted by it, Hemingway had nightmares after he went to sleep. He woke the whole household with his late-night yell. A couple years later, Hemingway retreated to his Uncle George's summer place in Ironton, on the other side of Lake Charlevoix, as a fugitive from the local game warden; Hemingway had impulsively shot a blue heron. He later confessed to a Boyne City judge, paid a fine of fifteen dollars and went home to help with harvesting the hay. In 1952, he fictionalized, and intensified, the incident in the "The Last Good Country"—an unfinished novella that was not published in his lifetime but was included in *The Nick Adams Stories* (1972).

In 1916, Hemingway took a fishing and hiking trip in the Upper Peninsula with his friend Lew Clarahan. After Lew caught a southbound train back to Chicago, Hemingway had seven hours to wait on the wooden platform for a train to Petoskey. He was increasingly serious about becoming a writer someday, so he spent the time making a list in the back of his diary of "good stuff" from the trip that he could turn into stories and essays. It came down to people and places: "(1) Old people at Boardman. (2) Mancelona Indian girl. (3) Bear Creek. (4). Rapid River." When Hemingway arrived in Petoskey, he walked over to the Hotel Perry and paid seventy-five cents for a quiet room. The next day, he hiked to Horton Bay, where the Dilworths fed him. In return, he helped with splitting wood and caught them eight rainbow trout in Horton Creek.

In 1918, Hemingway volunteered to be an ambulance driver during World War I. He served on battlefields in Italy. One hot July night, five weeks

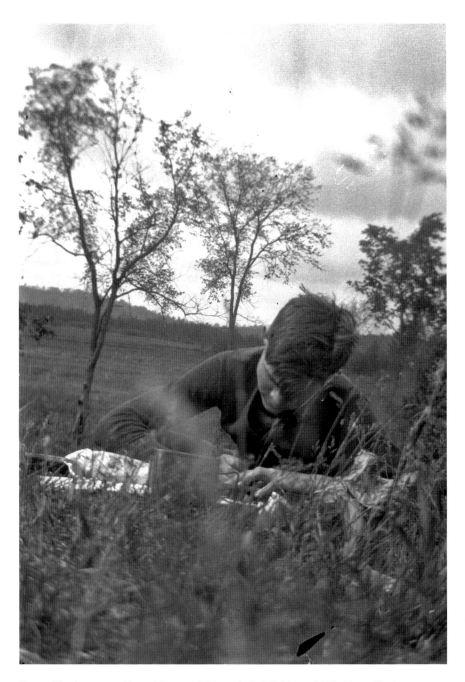

Ernest Hemingway writing while on a fishing trip in Michigan. 1916. *Ernest Hemingway Collection, John F. Kennedy Presidential Library and Museum, Boston.*

after his deployment and not long before his nineteenth birthday, Austrian forces fired a five-gallon tin full of metal projectiles into his camp. After the shock, Hemingway grappled for a wounded man near him who was crying. He lifted him up and carried him about fifty yards before he was shot in the leg by machine-gun fire. Somehow—Hemingway himself could never remember—he carried the man the remaining one hundred yards to safety before collapsing into unconsciousness. Hemingway convalesced in the north of Italy for five months, and for the rest of his life, he carried remnants of *scaggia* (shell fragments) in his legs. While in the hospital, he wrote postcards to his Northern Michigan friends: "Dear Auntie Beth, Save a place at the table for me…"

Back in the United States, he struggled with a limp and with what now might be called post-traumatic stress disorder. He was lonely and out of sorts. In early June 1919, Hemingway returned to Horton Bay to recuperate physically and emotionally. He stayed with friends, assisted with farm work and occasionally had the Boyne City doctor look at his legs. He returned to writing short stories.

In the meantime, Hemingway met Marjorie Bump, a charming Petoskey high school girl who waited tables at the Dilworth's chicken-dinner restaurant. Marjorie had a crush on the handsome writer who sat on the Pinehurst porch and smoked Russian cigarettes. Marjorie's name is echoed in two Nick Adams stories, "The End of Something" and "The Three-Day Blow." Another Pinehurst waitress, older than Marjorie, stayed on past Labor Day to help Auntie Beth wind down the restaurant after the tourist season. She and Hemingway took long night walks together, and on the large dock at the end of the sandy lane, they were intimate. Two years later, while living in Paris, Hemingway fictionalized the encounter in a story called "Up in Michigan." Because of its nature, it had trouble getting into print in the United States. In *A Moveable Feast*, Hemingway remembered writer Gertrude Stein's reaction upon reading a draft of the story.

> "It's good," she said. "That's not the question at all. But it is inaccrochable. *That means it is like a picture that a painter paints and then he cannot hang it when he has a show and nobody will buy it because they cannot hang it either."*

On his final fishing trip of the summer of 1919, Hemingway went to the Upper Peninsula with a couple friends. The train took them to Seney, about fifteen miles from Lake Superior. "It's great northern air," Hemingway

Ernest Hemingway with friends and sister Marceline in the Petoskey area. Summer 1920. *Ernest Hemingway Collection, John F. Kennedy Presidential Library and Museum, Boston.*

wrote, describing the north woods in a letter that year. "Absolutely the best trout fishing in the country. No exaggeration. Fine country. Good color, good northern atmosphere, absolute freedom, no summer resort stuff." In Seney, a railroad brakeman held the doors for Hemingway, who was still slow on his legs. The brakeman told the engineer, "Hold her up. There's a cripple and he needs time to get his stuff down." This astounded Hemingway, who was not accustomed to being seen as vulnerable. In fact, he put a good deal of effort in appearing just the opposite.

The Upper Peninsula fishing trip was the spark that ignited Hemingway's first great short story. He finished "Big Two-Hearted River" in 1924. In it, Nick Adams gets off the train in Seney. He hikes into the woods. He fishes for trout in the Big Two-Hearted—"clear brown water, colored from the pebbly bottom." Nick is haunted by something, but the text never tells the reader exactly what it is. Instead, Nick finds solace in ordinary rituals and practical tasks. He brews bitter coffee. He opens a can of pork and beans, which he cooks over the fire. He collects grasshoppers for bait. He sets up camp—"his home where he had made it." Fearing the feeling of being consumed, Nick avoids the swamp just up the river: "He felt a reaction against deep wading with the water

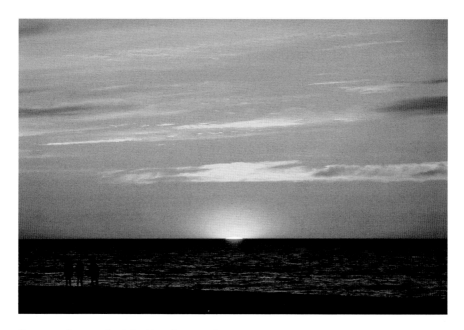

Sunset at the mouth of the Two-Hearted River, where it meets Lake Superior. July 2005. *Geoff George.*

deepening up under his armpits, to hook big trout in places impossible to land them…In the swamp fishing was a tragic adventure."

This sort of silence and repression was familiar to Hemingway, whose grandfathers were both Civil War veterans. The one on his mother's side, a thick-browed gentleman for whom Hemingway was named, had a Confederate Minié ball lodged in his thigh. Grace and Ed lived with him in Oak Park after their marriage, in the house where their son was born. Rather like Nick Adams, if not his grandson, the elder Hemingway never permitted the war to be discussed in his presence.

In his own retreat from the pain of war, Hemingway never actually made it to the Two-Hearted River, twenty miles north of Seney—a hike that is contracted in the story. Much nearer the Seney train station is the east branch of the Fox River, which teemed with brook and rainbow trout. This is where he and his friends fished on their Upper Peninsula trip; Hemingway boasted that they reeled in two hundred fish. He wrote later about substituting one river for another in his story: "The change of name was made purposely, not from ignorance or carelessness but because Big Two-Hearted River is poetry."

After a brief visit to Oak Park in October 1919, Hemingway returned to Northern Michigan. But this time, he removed himself from the pleasant distractions of the woods. He opted to live in a gabled rooming house at 602 State Street in Petoskey. Eva Potter, a widow, rented him a room with a view of Bear River for eight dollars a week. The plan: serious writing.

He clacked away on his typewriter, churning out page after page. He ate at Jesperson's, a diner with home-style food served on a long lunch counter. At McCarthy's Barber Shop and Bath Room, he got shaves and haircuts. When he needed a break from writing, he hooted and hollered at the bare-knuckle boxing matches in the park, or he played billiards at the Annex, a Lake Street saloon that probably inspired his story "A Man of the World." When friends interrupted his writing too often, Hemingway reportedly snuck into Evelyn Hall at Bay View, a Methodist cultural colony on a Petoskey hilltop. The expansive Queen Anne structure was a women's dormitory, built as a summer home for the Woman's Christian Temperance Union. Since it was unoccupied in the winter, he could commandeer the wood-burning stove and work in a quiet secret place.

In December, the Ladies' Aid Society invited Hemingway to give a talk about his war experience at the Petoskey Public Library, a handsome stone-and-brick Carnegie building on Mitchell Street. Approaching the spotlight with a fair bit of majesty, Hemingway wore his Italian cape with a silver clasp and polished boots. He exhibited the khaki breeches he had been wearing when he was shot, which were riddled with holes. He reflected on the long hours he had lain in a roofless stable before he could be taken for medical attention. That night, he told the Petoskey ladies, it seemed "more reasonable to die than to live."

One of the attendees of his library lecture, a genteel woman from Toronto, invited Hemingway to serve as a companion for her disabled son while she and her husband traveled for a few months in 1920. Hemingway accepted, and he took the opportunity to do some reporting for the *Toronto Star*. On his way back to Oak Park, he filed a piece for the Toronto newspaper on Canadian rumrunning, with stories gathered from Detroit and Ann Arbor.

After a short visit in his hometown, Hemingway was on his way back to Northern Michigan, this time bringing along his friend Bill Smith. When his family followed for their summer holiday, Hemingway was a constant source of exasperation for his mother. He spent too much time fishing and not enough time working. His father urged him to "try and not be a sponger"—Hemingway and his pals had a habit of enjoying the comforts of

The old Petoskey Public Library on East Mitchell Street. October 2014. *Anna Clark.*

Windemere while giving little in return. When he did do a bit of painting or dishwashing for his mother, he felt aggrieved at doing the work of, as he saw it, a hired hand.

"Everyone here knew Ernest Hemingway would never amount to a thing," H.G. Harris of Horton Bay, one of Hemingway's fishing buddies, told the *New York Times* in 1985. "He showed no sense of responsibility. He spent all his time fishing or hunting. Nobody believed it when he turned out the way he did."

After catching Hemingway on a secret midnight picnic on Ryan's Point off Lake Charlevoix, Grace's patience was tested to the limit. She banished Hemingway from Windemere until her son ceased his "lazy loafing and pleasure-seeking."

The young writer turned twenty-one in July. He lingered in Northern Michigan through the fall, thinking "long, long thoughts."

In what would be Hemingway's final summer in Northern Michigan, he married Hadley Richardson at the Methodist Church in Horton Bay. It was September 3, 1921. They had met in Chicago less than a year earlier. At the wedding, Hadley

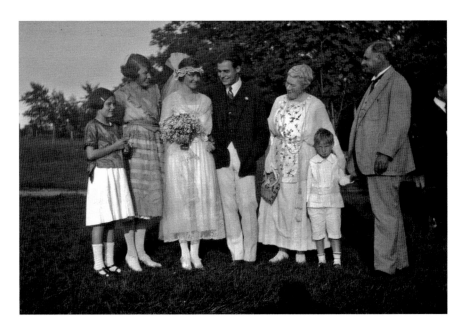

Wedding of Elizabeth Hadley Richardson and Ernest Hemingway, Horton Bay, Michigan. September 1921. *Ernest Hemingway Collection, John F. Kennedy Presidential Library and Museum, Boston.*

wore a wreath in her damp auburn hair; she had gone swimming in Walloon Lake earlier, and it had not quite dried. Hemingway, with his troubled legs, had difficulty kneeling in the church. The Dilworths hosted the wedding reception at Pinehurst—chicken dinner and champagne. The wedding announcement in the Petoskey newspaper called it a "pretty wedding."

In a sign of approval of the path her son had chosen, Grace offered to let the newlyweds honeymoon at Windemere. During their stay, Hemingway took a moment to add his signature to the cottage guestbook. Both he and Hadley caught colds and made mulled wine in the cottage as a cure. A local farmer drove them to the train station in Petoskey when their honeymoon came to an end. As they crested a hill, Little Traverse Bay emerged before them, a shock of brilliant blue against the bright red and yellow of the changing leaves. "See all that," Hemingway said grandly to his wife. "Talk about the beauty of the Bay of Naples! I've seen them both, and no place is more beautiful than Little Traverse in its autumn colors."

The couple made their way to Paris, where Hemingway worked as a foreign correspondent for the *Toronto Star*. The ambitious writer also had letters of introduction from Sherwood Anderson, author of *Winesburg,*

Ohio, tucked in his pocket, which would connect him to Gertrude Stein and Sylvia Beach, owner of the famed bookstore Shakespeare & Company.

In their two-room Paris flat, Hemingway reportedly pinned a map of Michigan to a wall by the place where he wrote his early fiction. In "a good café that I knew on the Place St.-Michel," he drank *café au lait* on a rainy day while writing in pencil in his notebook "about up in Michigan."

"Maybe away from Paris I could write about Paris as in Paris I could write about Michigan," he wrote in *A Moveable Feast*.

Indeed, it was in Paris that he hammered away at his stories of the north woods, among them "Big Two-Hearted River," "The End of Something," "The Three-Day Blow," "Indian Camp," "The Doctor and the Doctor's Wife" and "The Battler." He wrote many more tales of Northern Michigan throughout his life. He also penned a little satiric novella called *The Torrents of Spring*, a spoof of literary affectations set in Petoskey during the vernal equinox. And in the 1930s, he inherited Windemere.

But for all that, Hemingway returned to the north woods only once.

In 1937, he wrote a letter to his sister from Key West—a letter that sharply informed Marceline about who could and could not stay at Windemere. He also discussed returning to Northern Michigan for the first time since his honeymoon, but he never made the trip. "I've always been disappointed in places where I've returned," he later said. "I have such loving memories of Northern Michigan that I didn't want them interrupted." But on a long road trip to Sun Valley, Idaho, in 1947, when he was forty-eight years old, Hemingway went out of his way to pass through Petoskey for a night. It was a swift and cutting homecoming. He declared that Northern Michigan had become too civilized for his taste. After that, he returned only in his imagination and in the habits he adopted.

"The love of nature, of hunting and fishing, of the freedom to be found in the woods or on the water, stayed solidly with him to the end of his life," Baker wrote in his biography. "Nothing pleased him more than working up a good swinging sweat: He and his father both believed that it cleared the brain and cleansed the body."

The Hemingway cottage still stands. National and state historic designations acknowledge Windemere as a landmark, but it is still a private family residence. By 1985, one of Hemingway's sisters lived in Windemere, and as of this writing, her son, one of the writer's nephews, lives there. But the context of the old cottage is much changed. Large houses grew up around the once remote home. "Civilization" crept in.

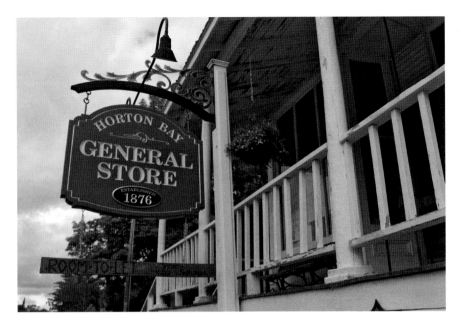

Horton Bay General Store on Boyne City Road. October 2014. *Anna Clark.*

The Horton Bay General Store, where Hemingway drank coffee at the counter, is still there. The church that stood next door to it, where he married, is not. In "Up in Michigan," Hemingway indicated that the general store doubled as a post office in his time; he remembered it "with a high false front and maybe a wagon hitched out front." The store is also probably the model for Mr. Packard's store in "The Last Good Country." Horton Bay General Store was in fact one of the earliest businesses to promote its connection to the writer. In 1985, the *New York Times* reported that it was "one of the few places in the area that sells Hemingway merchandise. A T-shirt with his picture costs $12.95."

Nowadays, Northern Michigan is finding new and thoughtful ways to tell its Hemingway story. The Hemingway Society produced a tour, with site markers and a brochure, to guide readers to key places in the writer's life, from Horton Creek to the old Carnegie library where he spoke to the Ladies' Aid Society. Each year, the society hosts a Hemingway conference. The Little Traverse Historical Museum—housed in the former Pere Marquette railroad depot, which the Hemingways likely used when traveling between Petoskey and Charlevoix—hosts a permanent exhibit called "Hemingway's Michigan Story." Pinehurst, the Dilworths' former home and business, first became a private residence and today is a vacation rental that promotes

its literary heritage—not only is it part of the stories "Up in Michigan" and "Summer People," but it was also a meaningful part of the Nobel laureate's life. Bookstores in Northern Michigan dedicate large storefront displays to Hemingway novels, story collections and biographies. And in the first iteration of the Great Michigan Read program in 2007, the state's humanities council selected *The Nick Adams Stories*. The book, it said, revealed how Michigan "played an essential role in [Hemingway's] development as one of the world's most significant writers."

But enthusiasts like Chris Struble, the Petoskey jeweler who directs the Hemingway Society, are most taken by the old black-and-white photos of the Hemingway summers in Northern Michigan. They remind him of his own life there: a place of cool waters and brisk winds, where the natural world is something that is lived in rather than looked at. In this corner of the world, Hemingway's extraordinary life looks ordinary.

"Look, he's wearing a T-shirt," Struble says as he stands at the glass counter of his downtown shop, clicking through Hemingway photos on his computer. "Look at these knuckleheads. He could be any kid."

Harriette Simpson Arnow's Mountain Path

W here rural and urban meet, you will find Harriette Simpson Arnow. This tiny, brash and big-hearted woman grew up in a lumber town on the Cumberland River, in a part of southern Kentucky set aside for Revolutionary War soldiers—veterans were given land, rather than money, for their service. Nearly all the residents in the town of Burnside, including the writer's family, were descendants of Revolutionary soldiers. Throughout her life, she kept her membership with the Daughters of the American Revolution up to date.

Both of Simpson's parents were teachers. Every expectation put her in front of a classroom as well. But she began to write stories when she was young. Writing was as natural as "knitting and crocheting are to other women." She typed one of her earliest efforts in 1921, a fairy tale about wildflowers talking to each other, and mailed it to a colorful magazine for kids called *Child Life*. When the magazine replied with a note that said a staff member had accidentally torn her manuscript and had re-typed it for her—this time with correct margins, spacing and a proper mailing envelope—Simpson took the quiet lesson in how to present her stories to editors.

Simpson studied botany and geology at Berea College, a small and strict work-study school that fetishized rural life in a way that grated on her. Tourists strolled through the campus craft workshop where she worked, and once, a woman looking at her speculated out loud that she must have come from an illiterate family. Jaw tense, Simpson kept her eyes trained on her work. But all her life, she regretted that she did not retort that her parents

were teachers, her aunt a county superintendent and she could count the wife of the first governor of Tennessee as a direct relative. And by the way, she could hear.

After her sophomore year in 1928, Simpson left to work as a country schoolteacher for two years and then enrolled at the University of Louisville. She fell in love with the city. She stayed in the uptown YWCA, near an excellent public library and a theater where she saw good plays. For the first time in her life, she met other people who were interested in literary writing; before then, writing for her "had always been a very lonely business." Members of a writing group invited her to join them, which spurred her to experiment more seriously with poetry and fiction. She took every literature class she could at the university. "I had an especially good course in Milton," she said. "I didn't like Milton, the way he treated his daughters and his ideas on women. But oh, his verse and his prose!" But Simpson still assumed she would have to be a teacher. She majored in science rather than English "because I knew I'd have to teach [English] and I felt it would be too great a pain to have to read the writings of [my] students, when I myself wanted to write."

A college friend inspired Simpson to spend the summer before their senior year working as a waitress at the Conway Inn on Crooked Lake, near Petoskey, Michigan. The pretty three-story resort was popular with vacationing families. Painted white with a green roof, it had an expansive porch shaded by tall leafy trees and an eight-stall boathouse on the lakeshore. The inn was hollering distance from the communities that Ernest Hemingway lived in and wrote about, but when Simpson arrived in Northern Michigan in the summer of 1930, Hemingway was nowhere near—he moved between a Wyoming ranch and a terraced home in Key West. He had just published *A Farewell to Arms*, and his most recent story collection was *Men Without Women*, which included "In Another Country" and "Ten Indians," both Nick Adams stories. "Ten Indians" ends with a spotlight on the Michigan landscape.

> *When he awoke in the night he heard the wind in the hemlock trees outside the cottage and the waves of the lake coming in on the shore, and he went back to sleep. In the morning there was a big wind blowing and the waves were running high up on the beach and he was awake a long time before he remembered his heart was broken.*

Like Hemingway, Simpson was an out-of-towner who fell in love with the north woods. Waitressing at the Conway Inn during the busy summer season still left her time to explore.

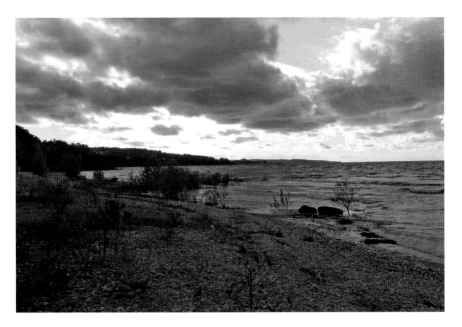

Shoreline of the Little Traverse Bay in Petoskey, Michigan. October 2014. *Anna Clark.*

Our hours were short. Then we could go swimming or canoeing or do whatever we wished to do. And northern Michigan was a revelation to me. I'd never seen birches, so many, you know. And the lakes and everything else; I just loved it…I would go down to Petoskey sometimes with the manager of the hotel, who went daily to buy fresh lake trout for the guests. And sometimes I would go with her. And at that time the Indians would come around with baskets to sell. I have the pieces of an old one; I'm crazy about basketry, though I've never tried to make one. And they would also sell wild raspberries and blueberries, which had an entirely different flavor and were better than the raspberries which came earlier and the blueberries and raspberries which are cultivated.

It was "a delightful world of blue water, blue skies, white birches, stump fences, swamps, and…leisure to enjoy it all." From the inn's owners, workers and guests, Simpson learned "something of the many ways of life in the state." One of her relatives lived near Detroit, which gave her the chance to discover the big city. Simpson also visited Ann Arbor. "My awe of the university…was almost matched by delight in the tree-filled town with its stately homes; and all around it the farmers' fields in which cattle grazed almost to the city limits."

She earned her bachelor's degree at the University of Louisville in 1931, less than two years after the Great Depression hit in the country, and she took a job teaching in a remote Kentucky community called Possum Holler. Simpson could not muster enthusiasm for teaching, but the village in the hills was life-changing for her. People in Possum Holler, living apart from the mainstream world, had developed profound familiarity with the natural world. Boys and girls climbed easily up eighty-foot trees and walked miles through the pathless woods without getting lost. As a guest in this community, Simpson boarded with a local family, walked to church on grass, learned sad songs about unrequited love and attended sewing bees. One day, she brought in an English lesson on nouns. Nouns are specific *things*, she explained to the young students. She held up a stout brown tree twig with a reddish bud at the tip. "This is a noun," she declared. Childish laughter broke through the room. No, the students told their schoolteacher. *That* was not a noun; it was a buckeye twig. And that light brown furrowed twig over there: that was not a noun either. It was a black walnut twig—they knew all the names of the sticks on Simpson's desk.

She returned to the Conway Inn in Michigan in 1934. It was the summer she turned twenty-six, and she was ready to begin her first novel, *Mountain Path*. The inn had several cottages on its grounds; guests who stayed in them could either cook their own meals or eat in the inn's dining room. When Simpson told Mrs. Trask, the manager, about her writing, she was offered one of the cottages rent-free. She gratefully accepted. She stayed in the cottage well past the turn of the summer season, fleshing out the cast of characters in her tale about an idealistic young woman from Lexington, Kentucky, who teaches in rural Appalachia and falls in love with a moonshiner. She wrote and wrote, and meanwhile, the tourists left and the air cooled. "And the leaves fell, and the lake…You know, it gets cold quite soon up there. It was beautiful."

Simpson left the cottage in November, but only because the Trasks spent their winters in Florida. "I thought I'd better be getting on." But writing in Michigan gave her the nerve to make her next great leap. "I would rather starve as a writer than a teacher," she decided. Rather than returning to Kentucky to teach, she moved to Cincinnati. She chose the city because it was bigger than Louisville, and she was eager for a place rich in literary culture and full of creative people. Cincinnati was a place where she could afford to make a go of it. "I was young and quick…I could live on coffee for two and three days at a time. I went to work when the coffee ran out."

Simpson lived at the top of an old downtown building, where street music poured through her window: boys hawking newspapers, cars wheeling

around corners, gossiping shopkeepers hollering to one another. She did typing work, waitressed and worked in the books section of a department store. She read Marcel Proust, Franz Kafka and Sigrid Undset, and she began to publish her fiction, initially in small literary magazines that paid only in contributor's copies. A story placed in Robert Penn Warren's *The Southern Review*, which paid $25, more than $400 in today's dollars, made her especially proud.

When *Esquire* accepted one of her stories—a tale about a confrontation between a seventeen-year-old boy and a deputy sheriff—it seemed like her big break. But this was the mid-'30s, the heyday of Hemingway, John Steinbeck and James M. Cain. Many publishers and readers were dismissive of ambitious female writers; even the most talented ones were relegated to a niche "ladies" market. *Esquire*, indeed, did not even accept submissions from women. So she disguised her gender: she published her story under the name H.L. Simpson. Assumptions being what they are, readers—then and now—expected that the author behind an initialed byline was male, and no questions were asked. "It worried me a little, that big lie," Simpson said later, "but I thought if they wanted a story, let them have it." She mailed them a photo of a male relative to be published in the "contributor's notes" section of the magazine. *Esquire* paid H.L. Simpson $125, or $1,300 in today's dollars.

An editor at a publishing company expressed interest in Simpson's work after reading it in literary magazines and, upon seeing a draft of *Mountain Path*, urged her to develop the novel's "action, sheer physical action." The story of a schoolteacher and moonshiner developed a gothic streak, with characters nursing mountain feuds and a pivotal act of murder. Three years after beginning the book, and after several coffee-fueled months of especially intense writing, she published it in 1936—a speedier arc than any book she later wrote. "Waitress Writes Book," reported one Cincinnati newspaper. Simpson's mother sent her a note: "Why don't you write about nice people?" But elsewhere, *Mountain Path* was celebrated. The *New York Times* praised its "stark beauty and sharp impact" and called Simpson a "remarkable talent." *Mountain Path* was a finalist for the 1937 Pulitzer Prize. "The author knows the people she describes, and makes them live," wrote the Pulitzer jury that recommended her. But another sort of Southern novel won the prize: Margaret Mitchell's *Gone with the Wind*.

After her book's publication, Simpson began working for the Federal Writers' Project (FWP) of the Works Progress Administration. Writers struggled during the Depression, earning pittances by churning out pieces for Sunday school newsletters and pulp magazines. With the FWP, Simpson

worked on guidebooks to Ohio, highlighting the state's scenic, historical and cultural resources. Her editor was a man named Harold Arnow, a Chicago native who had made his way to Cincinnati. He, too, was working on a novel; that was what first drew the couple together. Simpson was thirty-one when she married Harold, older than usual for the time, but then, she "wasn't eager to get married." She feared marriage would put an end to her writing.

The newlyweds were dreamers. They imagined a life where they could spend nearly all their time writing fiction, while doing just enough subsistence farming to get by. In 1939, the final year of the FWP, the couple moved to Pulaski County in Kentucky. They bought an abandoned farm on Little Indian Creek with a well-made log house on it. They read the *New York Times*, raised chickens, canned vegetables and wrote. Simpson Arnow began her great novel *Hunter's Horn*, a dramatic but understated tale of Depression-era Kentucky that drew from her experiences in Possum Holler. Around the same time, their daughter Marcella was born. But the Arnows realized that they were spending so much time on farm work, there was little time left for writing. Money grew tight enough that Simpson Arnow had to do more teaching, which effectively negated their reason for being in Pulaski County. They decided to join millions of other southerners who migrated north.

It was 1943, the peak of Detroit's dominance as the so-called Arsenal of Democracy, in which auto factories were repurposed for wartime industry. More than 1.6 million people lived in the city; the population had nearly doubled in the previous twenty years, and it was still on the rise. Quick growth and crowding incited racial and ethnic fears. Both the private and public sectors practiced blatant discrimination. At the same time, these were boom years for urban development in a tree-lined city that glittered with lights at night. There were more job opportunities for both men and women than ever before. The Arnows chose Detroit because Harold, who worked in newspapers in Chicago, thought he could get a job at the major dailies. (He became a reporter for the *Detroit Times*, which later was bought out by the *Detroit News*.) Harold left for Detroit first, intending to get settled before his wife and daughter followed. "When Harold arrived, there were stories in the Detroit papers relating how men were sharing rooms in shifts, three men to a room," Simpson Arnow said in a 1976 interview with the University of North Carolina's oral history program. "He came back to the farm once, only once, during the year or more before I joined him."

It was not easy for Simpson Arnow, and not just because of her husband's absence. Before Harold left, she gave birth to three children. Marcella, the eldest, was a lively little girl, but the second, a boy, was stillborn. They named

him Denney, which Simpson Arnow's mother preferred because it was her maiden name. There was a third child, too, a girl who had no name. She died a few hours after birth, and Simpson Arnow hemorrhaged in shock, requiring a blood infusion. The sadness of these losses brought more-than-ordinary tenderness and fear in Simpson Arnow's care of Marcella while her husband worked up north. When the girl suffered a high temperature and minor convulsions, Simpson Arnow hauled her up a muddy hill and hitched a ride in a coal truck to get to a doctor in town as fast as possible.

Simpson Arnow and Marcella joined Harold in Detroit in 1944. They settled in Emerson Homes, a wartime public housing development on the city's northeast side. Kitchens faced the alleyway, where children played. Little green lawns out front had spindly maple trees planted by the government, but roughhousing children usually killed them. Families of a minister, a police officer, a *Detroit News* deliveryman and factory workers made up their neighborhood.

> *Most women I met were like myself in that they, too, were wives with children, all of us, because of the war, uprooted to follow our husbands to Detroit…We grew to know each other better than those who study "the immigrant" by statistics built on direct questioning can ever know.*

Simpson Arnow was the only person she knew from southern hill country, though she did meet families from Georgia and Alabama. Being an Appalachian migrant in Detroit was not popular. Jokes about "hillbillies" abounded, even in newspapers. The writer's cultural tastes—she enjoyed the city's museums, theaters and libraries—shielded her from some of the backlash, but she was astonished to see newcomers blamed for everything from the three-day riot in 1943 to a supposed plague of "stupidity" in a worldly city. Rarely were Appalachian people credited for providing essential labor that kept the city's industry humming; indeed, many came north because of direct recruitment campaigns to "help win the war."

Perhaps the best thing that Simpson Arnow found in Detroit was time to write. "I always seemed to be able to write better in a city. I think a home in the country means more work and more distractions," she said. It wasn't until after she got out of the hills, she noticed, that she was interested in writing about them.

Simpson Arnow was half-finished with *Hunter's Horn* when she arrived in Detroit, and in 1949—after rewriting the first chapter seventeen times—she published the novel to great acclaim. It was a finalist for

the 1950 Pulitzer Prize, which Alfred B. Guthrie won for *The Way West*. MacMillan, her publisher, celebrated with a wine party at the glamorous Book-Cadillac Hotel in Detroit, "where I would have been more pleased had they served Old Grand-Dad," Simpson Arnow said, referring to her favorite brand of Kentucky whiskey.

Hunter's Horn features Nunn Ballew, a moonshine-making man in Kentucky who loves the old customs of Appalachia and dreams of bringing his farm back to fertility. But as urban values encroach on the Ballew family homestead, neighbors move to Detroit and Cincinnati, and city-educated women show up to teach their children. Nunn's daughter Suse finds solace in the beauty of Pilot Rock, where she lies on her stomach and writes letters. Here, "the bright, ever calling North seemed closer than on other days." Suse "wished she could…see Detroit…go to high school, get away from the Little Smokey Creek country."

The bestselling novel won the Book of the Year award from the *Saturday Review of Literature*, beating out George Orwell's *1984*. The *New York Times* named *Hunter's Horn* one of the ten best books of the year. The author herself believed it to be the best novel she ever wrote.

One of Simpson Arnow's favorite day trips with her family was driving to Ann Arbor. Compared to when she had first seen it as a college student, she noticed that the university was bigger, and there was more traffic, "but blindfolded Justice still held her scales above the old courthouse, with its worn stone steps and elm-shaded lawn."

> *Ann Arbor yet had her trees, though farmers' fields no longer ringed the town. I noticed, too, especially on Plymouth Road, that several barns appeared deserted and neighboring silos roofless. Yet, only a few miles away…well-kept homes and fields still spoke of abundance and peace.*

In 1950, the Arnows moved to a farm at 3220 Nixon Road in Ann Arbor. With wry humor, they nicknamed it Bedlam. There was a gravel road outside the house, but up the way, where the pavement started, there were large factories and a big housing development. Harold commuted to his job as a crime reporter in Detroit, and Simpson Arnow kept a large garden. Life was a mix of city and country. The author lived here until the end of her life.

She woke early to write: "I have awakened as early as 2:30 and gone to work on something, but not that often. I usually get up around five." After getting her kids (son Tom was now part of the family) and Harold off to school and work, she wrote for the rest of the morning. Then she "did [her]

cookery, housework, and remainder of the chauffeuring and shopping in the afternoon." She filled composition books and dime-store tablets with her barely legible black-pencil handwriting and then typed her second drafts on a portable Olivetti-Underwood. After that, her edits were a massive effort of (literal) cut-and-paste. "The most I do in a rewrite is cut, and still my books have too many details," she said. There was a daily tension between her responsibility to her home and her responsibility to her art. "I could have kept a better house…I couldn't write all day, although there were many days when I wished I could copy what I had written or take time to read it over, and I'd wish I didn't have to stop to do this or that."

She began writing *The Dollmaker* just before moving from Detroit. She wrote the first draft longhand, and Harold typed most of it for her. She published it in 1954—and it sat atop the bestseller list for thirty-one weeks. For a third time, Simpson Arnow was a finalist for the Pulitzer Prize. This time, she finished behind William Faulkner's *A Fable*.

But before the novel became a success, a motivated young editor at her publishing house arrived for a visit in Ann Arbor. He spent three days trying to convince her to change the novel so that it would have more "reader appeal."

"If this man knows so much about reader appeal, he'd be writing bestsellers himself," Simpson Arnow thought. But she let him prattle on. Before returning to New York, he handed her a copy of her manuscript with his edits on it. Simpson Arnow peeked at the pages and gasped: it had been slashed apart, nearly entirely rewritten. He had radically changed the country dialect language—which used grammar that was not officially correct but correct for its time and place—and polished off its edges, making it sound more blandly mainstream.

She could not sleep. Her heart thudded. "To thine own self be true," she told herself as she tossed and turned. When she woke in the morning, she added to her line of thinking: "And to your characters be true." And then she painstakingly subtracted the editor's rewrites from her manuscript.

Her insistence paid off. "Our most unpretentious American masterpiece," Joyce Carol Oates called *The Dollmaker*. A finalist for the National Book Award (again, beaten out by Faulkner), this "brutal, beautiful" novel is frequently compared to Steinbeck's *The Grapes of Wrath*. It is set in the last year of World War II, when a Kentucky family migrates to Detroit for work in "Flint's Motor Company," which is supplying military equipment. Gertie Nevels, our protagonist, is a woman who is bold enough to perform an emergency roadside tracheotomy on her son using only her whittling knife in the startling opening scene. She is practical and tough-minded, a would-be

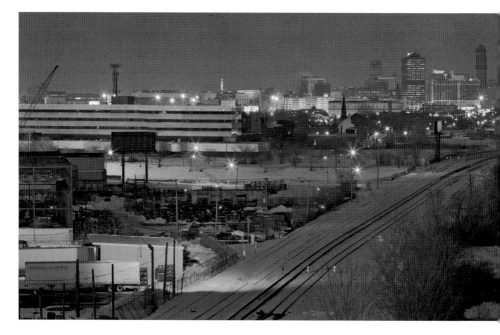

"Over the Tracks." Stitch of eight vertical images of downtown Detroit at dusk, with Michigan Central Station in the foreground. February 2009. *Geoff George*.

artist who is profoundly talented in woodcarving. When she and her children get on the long train north to Detroit to reunite with her husband, she hauls with her a large piece of fine cherry wood that she means to sculpt into a Christ figure—or something. She has a hard time picturing what its face should look like.

On the train, Gertie meets an African American woman with a baby on her lap whose husband is "a soldier man at a place called Grayling, past Detroit." She is traveling to Detroit's Paradise Valley, which she envisions as an urban splendor, fretting only that winter will be too cold for the baby. When the train arrives at the Michigan Central train station, the brutal winter day and the brusque crowd diminishes what would otherwise be a majestic gateway into the city. "I seed Dee-troit, Mom," Gertie's son reports, after he gets a glimpse outside. "I seed a million cars."

The Nevels family takes a pricey taxi to Merry Hill, a scanty housing development for "old man Flint's" employees. It is race-segregated "by law," but it is an ethnic stew—Poles, Irish, Catholics, Protestants—and residents, grasping for self-definition, unleash prejudices on those seen as "the other." They fear the end of the war because it threatens to make them unemployed.

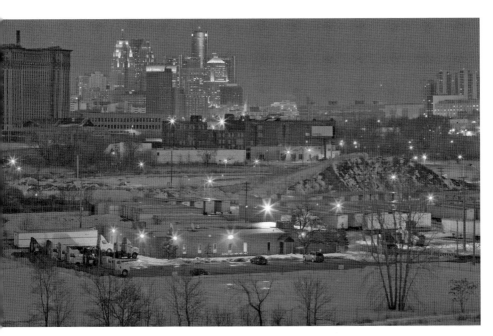

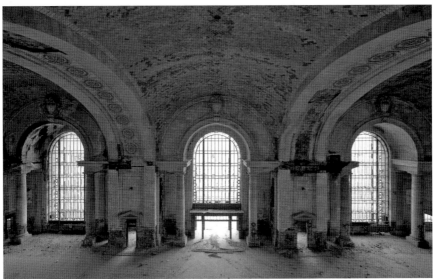

The former lobby of the Michigan Central Station in Detroit. August 2008. *Geoff George*.

They hear stories about people who find their way into a "mansion in Grosse Pointe," but it is a possibility that few find believable. One neighbor, Mrs. Miller, reflects on the closed-in feeling of the alley: "Yu know, back home

people'ull ast me, 'How was Detroit?' an I'll hate to say, 'I never did go down to lookut it.' Honest to God, I ain't never been downtown. I've allus kinda wanted to, an if I don't while I've got th chance I'll allus wish I had."

Gertie struggles to make a home for her family in a city that marks them as dirty hillbillies. "Liar, liar, liar, hillbilly," shouts one child in the alley, echoing what she's heard from grown-ups. "Yu mom never had no shoes till yu come to Detroit…Youse hillbillies come tu Detroit, and Detroit wenttu hell." At the same time, a kind of kinship, generosity, even friendship, emerges out of the forced intimacy of the crowded alley. There are no secrets here.

In the hills, the war experience was one of absence—disappearing men, scarce metals. In Detroit, the machinery of war is part of their everyday life. Walls are thin cardboard, light is bright and sharp, clocks tick and, when the freight trains pass, houses shake. Glaring lights from the fire of factory work distort the color of the night sky. A roving police presence puts their lives under surveillance. "Since u riots they go mostly in prowl cars, three by threes, sometimes two by two," a cab driver explains to Gertie.

From crowded public schools to the drumbeat of factory work, from debt as a way of life to green space sacrificed for industry, *The Dollmaker* is an unnervingly empathetic portrayal of the daily battles of survival. Simpson Arnow's picture of a crowded Detroit alley features an extraordinary ensemble cast, where diverse characters—children, too—must choose whether to fight for their individualism in a place that values the exact opposite. "Adjust! Adjust!" they are told again and again. Some do. Some do not. In either case, the consequences are astonishing.

After *The Dollmaker* had been out for some time, Simpson Arnow received a telephone call from a woman she had never met. The caller told the author that she perceived that the housing project in the novel was based on Willow Run, near Ann Arbor, where planes were made and many Appalachian families lived. The author told her it was not true; she had never been to Willow Run. No, the caller insisted. She was certain it was Willow Run because Homer—a minor character in the book who studies families in the development "as if they were bugs under the microscope"—was clearly based on her son-in-law, also named Homer. The writer could not get the woman to understand that the book was pure fiction; she did not write about her son-in-law. "She practically called me a liar, you see." The conversation quickly ended.

Simpson Arnow's daughter Marcella attended junior high in Ann Arbor, where a teacher asked the girl about her mother, who had written the popular books. This "embarrassed the child terribly." But it was also

3220 Nixon Road in Ann Arbor, where Harriette Simpson Arnow had a forty-acre farm. Fall 2014. *Megan Snow*.

rare. Ann Arbor is a city where children of university professors grow up, and they publish books themselves. The fiction writer living up on Nixon Road made few waves.

It was sixteen years before Simpson Arnow published her next novel, *The Weedkiller's Daughter* (1970). It is her only book set entirely in Michigan. The story unfolds in the fictional Eden Hills, a wealthy Detroit suburb, where the Schnitzler family lives in "a large executive home in a highly restricted neighborhood." Here, Simpson Arnow zooms in on the same questions of assimilation, self-preservation and suspicion of "the other" that she examined, in another context, in *The Dollmaker*. But she enlarges the picture by following two generations. Fifteen-year-old Susie is the daughter of Herman, a patriotic and conservative man who manufactures plastics used by the Department of Defense during the Vietnam War. They grow increasingly alienated from each other over their views on the war, racial politics, communism and the natural environment. Meanwhile, Susie's mother, her married older sister and her younger brother simply try to live "normal" lives. They are fond of, among other things, attending University of Michigan football games and participating in the "uncommonly large variety of clubs" in Eden Hills.

Susie, seeking alternative ways to live, finds her way to Mrs. Nevels, who lives alone in the country, where she gardens, raises livestock and makes wine. The local eccentric—nicknamed "The Primitive"—is, in fact, Gertie Nevels from *The Dollmaker*. We learn, with some relief, that she bought land in Michigan: "little hills if I can't have big hills." Herman refers to her as "that old hillbilly," but Susie situates herself at Mrs. Nevels's pond, where she writes letters to the editor under a phony name, protesting her father's pesticide campaign.

Susie also secretly visits her estranged grandmother, who was named in the McCarthy investigations as a "communist sympathizer." She skips her Saturday morning science club to take long bus rides to Ann Arbor, where, in the University of Michigan libraries, she could "learn how a normal American girl should be in matters psychological." And she finds solace in the city of Detroit, which she calls "my kind aunt." She loves "that wonderful little cafeteria on Eastern Market," and using the excuse of reading at the main library, she often wanders around the city alone for hours. Sailing through a storm on the Detroit River is an especially awakening experience.

> *The city could never be as alive, as exciting as Montreal; nor quaint like Quebec, an old great-aunt you loved to visit. Certainly Detroit was not as good for people-watching as even dear little Halifax, and could not compare with Edinburgh or London or Paris or Milan or Palermo or Mexico City, or many places she had visited with her grandmother on the yearly shopping and educational trip. Yet, whatever Detroit might lack, she was real and alive after the freezing chills of the ersatz world of Eden Hills.*

Susie's secrets pile up. In an effort to preserve her authenticity, she sneaks around, cloaking herself in lies and fakery. The tension cannot stand. Not long after she turns sixteen, things fall apart.

Reviews were not exactly triumphant for *The Weedkiller's Daughter*. Simpson Arnow was criticized for moving out of her perceived area of expertise—Appalachia. Her rendering of a teenager's viewpoint and of upper-class life felt one-dimensional to many readers. But it also had its admirers. The first fan letter she received for the book came from Alma College biology professor Ronald O. Kapp (who later had a science building at the college named after him). Kapp praised Simpson Arnow's effort at capturing the aching divisions of the era: "brainwashed vs. free, conformist vs. thinker, dominer of nature vs. lovers and preservers of nature, technocrats vs. humanists." She saved his note and wrote back to him:

Your opinion and the one review I've seen ease my mind considerably. I was afraid the work, if read at all, would be looked upon as one of two things: just another tale of a teenager in revolt against society and all it stands for, or merely a diatribe against all things in our way of life, from methods of secondary education to religion.

"I like *The Weedkiller's Daughter*," Simpson Arnow said, speaking later in life when the fame of *The Dollmaker* threatened to eclipse all her other books. "People ask me why I wrote it. Maybe I wrote it because I was tired of the mountains and had some things I wanted to say about the hypocritical North."

She also wrote social histories about the Cumberland Valley, as well as the novel *The Kentucky Trace: A Novel of the American Revolution* (1974). She published the memoir *Old Burnside* (1977) and posthumously, Michigan State University Press published *The Collected Short Stories of Harriette Simpson Arnow* (2005) and her novel *Between the Flowers* (1999). In 1983, *The Dollmaker* was adapted as a television movie on ABC, which won a Humanitas Award. Jane Fonda picked up an Emmy Award for her portrayal of Gertie Nevels. Fonda had visited Simpson Arnow during the filming to ask for help in adopting Gertie's hill country accent and manners of speech. "I guess she did all right," the author said. But the new wave of interest that followed the film had her complaining that she was "being drug into fame on Jane Fonda's coattails."

The same year as the film's release, Simpson Arnow was inducted into the inaugural class of the Michigan Women's Hall of Fame, alongside civil rights activist Rosa Parks and Pearl Kendrick and Grace Eldering, the Grand Rapids doctors who developed the first successful vaccine for whooping cough.

In her thirty-six years in Ann Arbor, Simpson Arnow saw the city change "a very great deal." She kept up community ties, but she held herself at some remove. She gave lectures to labor history classes at the university. She participated in local chapters of the American Civil Liberties Union and Planned Parenthood, and she was a member of the Women's International League for Peace and Freedom. In the 1968 presidential election, she cast her ballot for Eugene McCarthy. An "excellent woman writers' club" in Ann Arbor invited her to join, but their evening meetings were difficult because "it interferes with the next morning's writing."

She sometimes took Marcella to Detroit, where they had lunch on the thirteenth floor of J.L. Hudson's Department Store. "We tried to get there

A snowy night on State Street in Ann Arbor. December 2005. *Geoff George.*

early enough to have a table by a window in the dining room high above Detroit. There, we could as we ate watch the life of Detroit below us." Marcella grew up to earn her economics degree from the University of Michigan after spending a couple years at Swarthmore College in Pennsylvania.

"Several men have, through the years, said to me: You write like a man," Simpson Arnow said in a 1973 interview. "They consider this a compliment. I want to ask: Which man? I never have. Without the answer, I do not feel complimented."

In February 1985, Harold died. Just over a year later, on March 22, 1986, Harriette followed, dying in her sleep at her Ann Arbor home. She was seventy-eight years old.

"I have never written to please anyone," she said once. "I try to get what's in my head onto paper, which isn't always easy because I don't always think in words. I think in images."

Simpson Arnow used to joke that she wanted to spread her ashes on the grave of Ronald Reagan. But in fact, she is buried in the old family graveyard in the Kentucky hills of Pulaski County. She rests next to Harold and their two stillborn infants. It's the same part of the hills where, long ago, she and Harold thought they would make their lives.

Chapter 3
Poets of the City

Robert Hayden and Dudley Randall

Robert Hayden, who would become the first African American to be named poet laureate of the United States, was given away to his next-door neighbors when he was eighteen months old. His foster parents changed his name from Asa Bundy Sheffey, a name Hayden did not know about until he was in his fourth decade. The duality of the life he might have lived haunted him.

Paradise Valley was the cultural center of Black Bottom, the bustling near-east neighborhood where most of Detroit's African American residents lived. Hayden lived until he was about ten at the corner of St. Antoine and Beacon—today in the shadow of Ford Field, where the Detroit Lions play. St. Antoine teemed with restaurants, barbershops, pool halls and drugstores. On summer nights, children played hide-and-seek, using a lamppost as the base. A waffle wagon rang a tinkling bell. In the 1930s, as international tensions leading to World War II were building, Joe Louis—a black Detroiter from their own neighborhood—twice defeated German champion Max Schmeling in the boxing ring. People rushed out to St. Antoine to hoot, holler and hug their neighbors.

"St. Antoine was the parade ground for people from everywhere in the world," Hayden said. "That was the place where the street preacher was most likely to attract an audience; so they'd get out on the corner to preach, sing, and shake their tambourines and all that."

Hayden returned to Paradise Valley throughout his writing life. He described the ethnic mix of immigrants turning increasingly African

American: "But the synagogue became / New Calvary. / The rabbi bore my friends off / in his prayer shawl." In "Sunflowers: Beaubien Street," Hayden pictured families planting "hot-smelling" sunflowers "round door and wall" of their crowded homes. And his poem about Theodore "Tiger" Flowers, the first black boxer to win a championship title since Jack Johnson, showcases the neighborhood's entrepreneurial corner life:

> *The sporting people*
> *along St. Antoine—*
> *the scufflers'*
> *paradise of ironies—*
> * bet salty money*
> *on his righteous*
> * hook and jab*

While Paradise Valley was often vivid and joyful, it was also sometimes a place of cruelty and rage. "Elegies for Paradise Valley" opens with dark details that contrast with the poem's idyllic title:

> *My shared bedroom's window*
> *opened on ally stench.*
> *A junkie died in maggots there.*
> *I saw his body shoved into a van.*
> *I saw the hatred for our kind*
> *glistening like tears*
> *in the policeman's eyes.*

Second Baptist Church on Monroe Street was Hayden's childhood church, "the center of family life." He went to Sunday school and vacation Bible school there, and he served as president of the Baptist Young People's Union. He also wrote for the church paper. In 1937, the church's Paul Robeson Players staged the only performance of Hayden's play *Go Down Moses*. (The play was lost before it could be staged again.) But Hayden felt detached from the strict religiosity of his youth, and in the early 1940s, when he married Erma Inez Morris, a woman of the Baha'i faith, he converted.

Hayden attended his senior year at Northern High School on Woodward Avenue at a time when it had a largely white student body. He transferred from the predominately black Miller High School because his eyesight was poor; Northern was considered a "sight-saving" school. But perhaps no school could

protect the extremely nearsighted Hayden from teasing about the oversize glasses that seemed to swallow his face. He writes in his poem "Names:"

Four Eyes. And worse.
Old Four Eyes fled
to safety in the danger zones
Tom Swift and Kubla Khan traversed.

As a senior, Hayden worked on a manuscript called "Songs at Eighteen" that he tried, unsuccessfully, to publish. But he did win an award for a short story called "Gold." He graduated in 1930, right into the throes of the Great Depression. After a brief stint at what is now Wayne State University, Hayden signed on to work for the Detroit branch of the Federal Writers' Project, just as fiction writer Harriette Simpson Arnow was doing around the same time in Cincinnati. Hayden's job was to research black history. He also worked on his poetry, though in the Depression-era labor movement, he met with a fair share of raised eyebrows. His chosen craft hardly seemed practical. Still, labor organizers embraced a choral poem he wrote called "These Are My People," performing it in Chicago and Detroit to rousing crowds. Hayden also found a group of literary enthusiasts who, like him, admired John Keats and aspired to write "immortal poetry." At the main branch of the Detroit Public Library, a woman named Alice Hanson ran a room dedicated to poetry; she set aside new volumes for Hayden, who could not afford to buy them for himself.

Hayden is not the only writer shaped by Paradise Valley and Black Bottom. Dudley Randall, founder of the groundbreaking Broadside Press, also wrote about it in poems like "Laughter in the Slums" ("In crippled streets where happiness seems buried / under the sooty snow of northern winter…") and "Ghetto Girls" ("Eyes where the morning stars yet glimmer on; / Feet swift to dance through juke-box nights till dawn…"). The latter was originally titled "Hastings Street Girls," after the pulsing street that was the center of Paradise Valley nightlife.

Randall's and Hayden's portraits of Black Bottom stand in contrast to Jeffrey Eugenides's version of it in *Middlesex*, a novel that highlights the neighborhood as the birthplace of the Nation of Islam. While Randall and Hayden wrote about it from the vantage point of day-to-day life, Eugenides took on the perspective of a visitor. When one character rides the streetcar that crosses Hastings Street, "every passenger, all of whom were white, performed a talismanic gesture. Men patted wallets, women refastened

purses…The light seemed to change, growing gray as it filtered through laundry lines."

Randall had a different kind of childhood than Hayden. His parents were middle class and college-educated. He was a student at Duffield and Barstow elementary schools, attended Plymouth Congregationalist Church with his family and belonged to the Boy Scouts. Randall's family encouraged his interest poetry, and his home brimmed with books, including international titles. When Randall was thirteen, he won a writing contest: the *Detroit Free Press* published his first poem and paid him one dollar. In 1930, he graduated from Eastern High School at age sixteen.

Randall and Hayden, born five months apart, might have missed each other completely if it had not been for an employee at the YMCA. Both attended Y programs, and in 1937, a staff member approached Randall: "Since you are interested in poetry, you ought to meet this guy named Robert Hayden. He's a poet, too."

"We got together and showed each other our poetry, and criticized each other's poetry," Randall remembered.

They went together to see Billie Holiday at Club Plantation in Paradise Valley. The striking flower in Holiday's hair romanced Hayden; Randall remembered feeling out of place in a glamorous club. Throughout their life, the two men exchanged thoughtful letters that explored poetry and philosophy, edged with a competitive spirit. In the Cold War era, when there was narrowed access to world literature, both shared a passion for international culture. In short, Hayden and Randall had overlapping but distinctive lives of intellectual curiosity, social engagement and poetic grace.

Hayden's great subject is memory, which he approached with what Gwendolyn Brooks called "bits of languorous lyricism, which have as much right to live as have roses." It is ironic, then, that Hayden wished only to preserve his writing that appeared after 1962. He dismissed his early poetry as "'prentice pieces." It's true that his craft as a younger poet was less skilled. He outgrew the politics his early poems held close. But there is still power in remembering his whole story.

In 1938, the year after he met Randall, Hayden started classes at the University of Michigan in Ann Arbor, pursuing his degree with newfound

Robert Hayden with Samuel H. Thomas, president of the Friends of the Detroit Public Library, at a poetry reading at the Main Branch. October 1978. *Burton Historical Collection at the Detroit Public Library.*

intensity. He won two Hopwood Awards for his writing and published his first volume of poetry, *Heart-Shape in the Dust*. He also studied under poet W.H. Auden, who "stimulated us to learn more about poetry in a way that we never would have been had it not been for him." Hayden's daughter was born while he was still studying, and Auden came to visit the proud parents and their newborn. "He was eager to see what she looked like, and so he looked down on her in her crib," Hayden remembered. "I've told her, 'You must remember always that W.H. Auden came to

Angell Hall, which houses the English Department at the University of Michigan in Ann Arbor. Fall 2014. *Megan Snow.*

look at you.'" Hayden stayed in Ann Arbor for graduate work, earning his master's degree in English in 1944. Three years later, he published one of his best poems, "Frederick Douglass," in the *Atlantic Monthly*. He autographed a copy and sent it to Alice Hanson at the Detroit library. She showcased it in a special display in the lobby.

Not long after, Hayden left Michigan for Fisk University in Tennessee, where he taught for twenty-six years. Moving from Michigan to the South was not easy; Hayden refused to see movies in Nashville because the theater had segregated seating. In 1969, he returned to teach at the University of Michigan. He set up shop in the English Department in Angell Hall, where he had once taken classes, and he remained there until the end of his career.

In naming 1962 as his turning point—the line between "'prentice" and artist—Hayden counted from the publication of *A Ballad of Remembrance*. It found success that year in the United Kingdom, catalyzing his career in the United States. *A Ballad of Remembrance* includes Hayden's iconic poem, "Those Winter Sundays," a three-stanza crystal cut into cool rhythm. It begins as if the speaker were partway through a story:

Sundays too my father got up early
and put his clothes on in the blueblack cold,
then with cracked hands that ached
from labor in the weekday weather made
banked fires blaze. No one ever thanked him.

Hayden was culling from the fraught dynamics in his Paradise Valley household. His family struggled with money, marital problems and tension between Pa Hayden and children from his mother's first marriage. The poem opens in the early hush before Sunday church at Second Baptist. Pa Hayden, a laborer, ignited young Robert's fear of "chronic angers of that house." At the same time, he encouraged the bookish boy toward a better life. "Get something in your head, and then you won't have to live like that," his father used to tell him. Years later, Hayden said, "What hurts me is that he never lived to know that I cared that much."

A Ballad of Remembrance also includes "Middle Passage," another of Hayden's best-known poems. In multiple voices, it dramatizes the 1839 slave revolt on the ship *Amistad* in a collage of dialogue, diary, hymns, ship's logs and narrative. It remarks on the names of slaving ships—*Estrella, Mercy, Desire, Jesús*:

…the dark ships move,
their bright ironical names
like jests of kindness on a murderer's mouth.

Hayden published with small presses for the first forty years of his writing life. While this brought a personal touch to his work, it also meant his poems did not reach a large audience. In the early 1960s, Hayden approached a major East Coast publisher, armed with a manuscript of his best poems and letters of support from the leading poets of his generation. But the acquisitions editor turned him away. "We already publish a Negro poet," he explained.

Back in Detroit, Broadside Press was born in 1965 in the Russell Woods home of Dudley Randall. The same year, Motown Records had number-one hits with "My Girl," by the Temptations; "I Can't Help Myself," by the Four Tops; and "Stop! In the Name of Love," by the Supremes. What the

Dudley Randall, poet and founder of Broadside Press. *Courtesy of Melba Joyce Boyd.*

groundbreaking recording company did with music, Broadside did with literature. Publishers did not take African American talent seriously, so it was time to create new publishers. Motown, too, operated out of an ordinary house rather than a slick office—a two-story on West Grand Boulevard, four miles from Broadside's first headquarters at 12561 Old Mill Place.

As a leading force in the Black Arts movement, Broadside enriched national culture by publishing Gwendolyn Books, Louise Clifton, Sonia Sanchez, Etheridge Knight, Pearl Cleage, Haki R. Madhubuti, Nikki Giovanni and Hayden. Audre Lorde's Broadside book *From a Land Where Other People Live* (1973) was a finalist for the National Book Award. When writer Adrienne Rich was announced as the winner that year, Lorde joined

her onstage along with fellow finalist and Broadside poet Alice Walker. "We, Audre Lorde, Adrienne Rich and Alice Walker, together accept this award in the name of all the women whose voices have gone and still go unheard in a patriarchal world," Rich said, "and in the name of those who, like us, have been tolerated as token women in this culture, often at great cost and in great pain."

Let's be clear on the stakes here. Between 1966 and 1975, Broadside Press published eighty-one books, nearly all of them poetry. This was more than twice the number of titles by black poets produced by all United States publishers in the previous two decades *combined*. Melba Joyce Boyd points this out in *Wrestling with the Muse*, her essential book about Randall and the press. Boyd adds that only nine of the thirty-five books published by black poets between 1945 and 1965 had national distribution. In contrast, Broadside books each had a printing run of at least five thousand copies.

Broadside, then, brought a national and world audience to its writers. It also published tapes, posters, an African cookbook and children's books. It did this with no serious financial backing. At the same time, Broadside retained its civic engagement in the community that gave rise to it. Randall himself was a Detroit city employee in the 1960s—a librarian at the Parkman branch.

He had taken a circuitous path to the circulation desk. In the 1930s, Randall worked in a Ford Motor Company foundry as a United Auto Workers member and later worked as a postal carrier. He was drafted into the military in 1943, serving in the South Pacific as part of a segregated army. After the war, Randall returned to work at the Postal Service while finishing his English degree at Wayne State University. He also studied Russian language and literature. In 1951, when he was in his mid-thirties, he graduated from the library science program at the University of Michigan. After serving in library posts in Missouri and Maryland, Randall returned to his home city.

Al Ward was a young man in the mid-1960s and a passionate reader. When his neighborhood library on Oakman Boulevard hosted a poetry workshop, he went. There, he met Randall. Rather like how Alice Hanson encouraged Hayden in the poetry room of the Detroit library, Randall supported Ward's interest. "I decided to bring my little poetry, and he looked at it and he liked it," Ward told me. Years later, Ward enrolled at what is now the University of Detroit–Mercy, and he again ran into Randall, who had become the university's reference librarian. Ward was coming of age, and the poetry workshops and readings that Randall hosted at the library had a tremendous impact on him.

McNichols campus of the University of Detroit–Mercy. Fall 2014. *Nick Hagan.*

"Dudley was bringing to the forefront all of these voices dealing with the issue of the struggle of black people in dealing with a tradition of discrimination and inequality and so forth," Ward said. He later became a Broadside-published poet himself and a board member of the press. UDM's McNichols Campus Library features a national Literary Landmark plaque honoring Randall and sponsors the Dudley Randall Center for Print Culture.

As a poet of memory, Hayden poses reflective questions. "What did I know, what did I know / of love's austere and lonely offices?" he asks at the end of "Those Winter Sundays." And, in "Astronauts": "What do we ask of these men? / What do we ask of ourselves?" This seeking spirit brings spaciousness to Hayden's elegies. He wrote somber poems about the Holocaust in "Belsen, Day of Liberation" and "From the Corpse Woodpiles, From the Ashes." The title poem of his 1970 collection, *Words in the Mourning Time*, eulogized the assassinations of both Dr. Martin Luther King Jr. and Robert F. Kennedy. It also grieved for the war on Vietnam as it dragged into a new decade. While writing the *Mourning Time* poems, Hayden was "terribly worked up."

Staircase in the Main Branch of the Detroit Public Library. Fall 2014. *Megan Snow.*

I suppose that series of poems was my way to catharsis because in the 1960s I very often felt that I could not stand the horrors of that period…The only way I could bear it and understand it and handle it was to write out my feeling about it…It was my way toward resolving anxieties and fears and the great overwhelming sadness I found at that time.

Hayden dedicated *Words in the Mourning Time* to Alice Hanson, who put countless books of poetry in his hands. His book was a finalist for the National Book Award.

The poet also frequently shone a light on figures in history, including Sojourner Truth, Phillis Wheatley, Bessie Smith, John Brown and Paul Laurence Dunbar. Provoked by the 1964 murders in Mississippi of three civil rights workers, whose youthful faces reminded him of his students, Hayden wrote the mesmeric poem "Night, Death, Mississippi." And in "El-Hajj Malik El-Shabazz," he put together a four-part sequence about the man more commonly known as Malcolm X: "He X'd his name, became his people's anger." Reading *The Autobiography of Malcolm X*, published after the minister's murder, Hayden reflected on how the man who was called "Dee-troit Red" in his youth lived a life that incarnated "the theme of metamorphosis."

He fell upon his face before
Allah the raceless in whose blazing Oneness all
were one. He rose renewed renamed, became
much more than there was time for him to be.

While Randall is most famous for launching the careers of dozens of the nation's most talented writers, his own poetry is nothing to take lightly. Like Hayden, Randall did not shy away from the burning issues of his time. In 1965, he published "The Ballad of Birmingham" on a single sheet of paper—that is, the "broadside" of his publishing company's name. "Ballad" is about the 1963 church bombing that killed four girls in Alabama. A girl sees other children participating in Freedom Marches and asks her mother if she can join them "to make our country free." "No, baby, no, you may not go," her mother replies because she is afraid "those guns will fire." When she sends her daughter to church, "the sacred place," she trusts the girl will be safe and well kept. But the explosive backlash to the civil rights movement strikes there, too.

O, here's the shoe my baby wore
but, baby, where are you?

Written largely in dialogue between mother and daughter, "Ballad" reveals how Randall viewed politics as a matter of the heart. His clean, spare language mirrored his personality. Randall was no showboat. "I was a preacher's son, and heard too much preaching at home," he said. "I believe that readers instinctively resist a writer who has an obvious design on them, who too obviously tries to manipulate them."

Randall's quiet style entranced a younger generation of writers. Ward, the young writer who met Randall at the Parkman library, noticed "the famous poet" walking around the neighborhood from time to time. Randall impressed the twenty-year-old with his warmth, approachability and encyclopedic knowledge. One day, Ward cycled through the streets, looking for Randall's house. When he found it, he leaned back on his bike, and for two hours, he simply stared at it. Here was a regular-looking home. Inside, an extraordinary artist lived.

In 1968, Randall published a cycle of thirteen poems called *Cities Burning*, his answer to the "long hot summer" in Detroit the previous year, which

ruptured into violence. It was his first collection of poetry as a solo author. As Randall put it, the book embodies "the disturbed feelings and the violent events of our disturbed and violent times." It includes one of his most well-known poems, "Booker T. and W.E.B," which imagines a dialogue between Booker T. Washington and W.E.B. DuBois about living a dignified life. (They do not agree.)

Cities Burning sold for one dollar a copy in its first edition. The back of the book featured a listing of individual poems available from the publisher as broadsides—from Langston Hughes's "Backlash Blues" to Naomi Long Madgett's "Sunny"—for fifty cents apiece.

Hayden refused allegiance to the Black Arts movement. He insisted on independence even from those whose beliefs and identities he shared, and he defied the instinct for people to read poems by black artists as if they were sociological documents rather than literature. This resulted in tremendous antagonism toward him. Tension broke at the 1966 writers conference at Fisk (which Randall attended; he stayed with the Haydens). On a writer's panel, Hayden was criticized for not being "black enough" because he was unwilling to identify primarily as a "black poet." Hayden insisted he was a poet first. Critics questioned whether Hayden was an Uncle Tom, more interested in appeasing a predominantly white literary establishment than supporting his community. In a culture of tremendous racism, they felt that black artists had a responsibility to devote their work to the liberation of black people.

Hayden, however, took William Butler Yeats as his model for literary citizenship:

> *I think I always wanted to be a Negro poet or a black poet or an Afro-American poet—we'll use all the terms and be done with it—the same way Yeats is an Irish poet...Yeats did not flinch from using materials from Irish experience, Irish myths. The whole Irish struggle has meaning for Yeats. He would have been astonished if anyone had told him to forget that he was Irish and just write his poetry. But he wrote as a poet; and I am not Irish, but could read Yeats' poems, such as "Easter 1916," and relate to it. When I was teaching at Terre Haute one summer, teaching a course in contemporary poetry—it was right after the Detroit riots—I remember going to class one morning; we were working on Yeats, and we*

had that poem, "Easter 1916." I began to read the poem and could not go on reading it: the tears welled up...It was a very moving experience reading that poem after the Detroit riots. Well, Yeats didn't write that poem for me particularly, but that is the kind of poetry I want to write.

Hayden was more blunt in another interview:

[Yeats] struggled—an artist who had to come to grips with being Irish, who was disliked by the Irish even, because he did not do what they expected him to do. You know, I feel myself pretty much in the same situation very often. During the 1960s, I drew a lot of strength from knowing what Yeats had gone through.

Randall was more energized by the fiery literary climate of the time, but he was also an introvert. He admired Hayden for standing up for what he believed in. "I'll never forget those crisp shrimps or that breakfast formidable, or our talks in the evening over coffee," he wrote in a thank-you note to the Haydens for their hospitality during the Fisk conference. In a follow-up letter, he said that the conference was "very interesting but a little too strenuous for me. I think I'll sit the next one out, and, as Ossie Davis suggested in his speech, stay at home like a writer and write."

A passionate traveler, Randall visited the Soviet Union in 1966 and studied in Ghana in 1970. He also visited France, Togo, Czechoslovakia and, as a soldier, the Pacific Islands. He was unceasingly interested in the diversity of world languages. Among other works, Randall translated poems by Alexander Pushkin and Konstantin Simonov from Russian to English. He concludes his second Broadside collection, *After the Killing* (1973), with Pushkin's poem of heartache, "I Loved You Once."

I loved you so intensely, tenderly
I pray to God some other love you so.

"Study of a foreign literature will broaden you and give you a perspective on poetry written in your own language," Randall said. "In short, you should open yourself to all of life, to all experiences, to all of

mankind, to the whole rich, bustling, wonderful world, which you will transmute into poetry."

Today, Broadside continues to publish and issue reprints of its classic work. It hosts readings, performance theater projects and young writer programs. In Idlewild, Michigan, the legendary resort community for African Americans, it led an oral history project. It also runs the Institute of Cultural Studies, a series of workshops where participants read the poems of Broadside. As board member and poet Aurora Harris told me, readers "relate them to the struggles of the past and today."

It all connects to Broadside's primary purpose: through literature, the press cultivates a sense of ownership among citizens for their own story. Harris calls it "being part of a family and community of legacy keepers."

———

Hayden was in his sixties before his literary career was honored. President Gerald R. Ford appointed Hayden as the United States poet laureate in 1976. It was a big leap for the writer who, only five years before, had been described by the *New York Times* book review as "one of the most underrated and unrecognized poets of America." In January 1980, President Jimmy Carter celebrated Hayden's contributions to American poetry at a White House event. When Hayden found he had no identification number to pass through Secret Service, his resourceful wife pointed to his photo on a book jacket. They made it through.

Scarcely more than a month later, the University of Michigan hosted "A Tribute to Robert Hayden." But the poet could not attend; he was bedridden with cancer at his Ann Arbor home. His old friend Dudley Randall attended the tribute, however, and afterward, he stopped by the Hayden household on Gardner Avenue to say hello.

Randall wasn't doing well, either. He suffered from a depression that had been lingering for years. He grieved for what he felt was his insufficient literary work. He could not write. He struggled with suicidal thoughts.

On that brisk February day, the sun dimmed in an early twilight. Hayden offhandedly mentioned that he no longer had a single copy of one of his books, *Night-Blooming Cereus* (1972). How strange! Where had they all gone? When Randall returned the following day, February 25, he gave the poet a copy of the book. It was their final meeting, and Hayden, whether he knew it or not, gave Randall an important gift. Boyd describes it in *Wrestling with the*

Number 1201 Gardner Avenue in Ann Arbor, the final home of Robert Hayden. *Megan Snow.*

Muse: "Hayden encouraged Dudley to appreciate the importance of his own existence, to abandon this gloom and regret. He praised Dudley's poetry and encouraged him to write, to carry on." Later that same day, Hayden died at age sixty-six.

A few weeks after his friend passed away, Randall sat down at the typewriter and began to peck at the stiff keys. Within a year, Mayor Coleman A. Young named Randall the first poet laureate of the city of Detroit, an honor that took his breath away. "Part of a poet's work," Randall said, "is to look at people. And it's the people in this town that make it such a poetic place, more than New York, London, even Paris."

The same year, 1981, Randall published *A Litany of Friends: New and Selected Poems*, a book divided into five sections: Friends, Eros, War, Africa and Me. Fifteen years after that, the National Endowment of the Arts gave him a lifetime achievement award. Most importantly, poets whom Randall supported and influenced—among them, Melba Joyce Boyd, Al Ward and Aurora Harris—launched their own artistic careers, and they never forgot his help in making it happen. When Randall died at age eighty-six on August 5, 2000, there was no question about his legacy. He cracked open American literature, bringing forth rich and brilliant voices that collectively rewrote the literary canon.

Randall is buried in Detroit's Elmwood Cemetery, where he rests alongside other pioneering people, from Michigan territorial governor Lewis Cass to Detroit's first black schoolteacher, Fannie Richards. Hayden is buried in Fairview Cemetery in Ann Arbor, a lush and peaceful corner of a bustling city. The earliest burials in Fairview date back to the 1830s, a generation before the Civil War.

Chapter 4
The Detroit Fiction of Joyce Carol Oates

J ust two years after the U.S. census marked the first time Detroit's population had ever declined, a young writer began her first teaching position at what was then called the University of Detroit. She and her new husband rented an upstairs apartment on Manderson Road near Palmer Park, where they would come to enjoy taking long walks in the leafy neighborhood. She was twenty-four years old. A world of glittering possibility lay before her.

"Often I think about Detroit, which was the city of my young married life," Joyce Carol Oates told me when I interviewed her for the *Detroit Free Press* in 2014. At the time of this writing, she is seventy-six years old and the author of more than fifty novels, as well as dozens of story collections, essays, plays and volumes of poetry. Her first book, *By the North Gate,* was published in 1963, not long after she arrived in Detroit. She followed up with the novel *With Shuddering Fall* and was well on her way to an exceptional career in American letters. Oates's writing life has spanned more than half a century, highlighted by the National Humanities Medal, two O. Henry Awards and a National Book Award.

Much of her literary work draws from Detroit, a region she called home for nearly two decades. That era, Oates told me, is "a richly nostalgic time both for me and for the city itself, which was in a 'boom' phase at the time financially. Then, with the so-called riot of 1967, that era ended abruptly."

Or, to put it another way, moving to Detroit "changed my life completely," Oates told another interviewer in 1985. Living in the city at a time of both urbane glamour and simmering inequality "made me want to write

directly about the serious social concerns of our time. I wanted to write about individuals who were also participants in a vast social drama—the complexity [and the tragedy] of which they barely grasped."

Her most celebrated novel is *Them*, which won the 1969 National Book Award and is part of the Wonderland Quartet, a loosely connected series that examines questions of twentieth-century social class. *Them* is a stringent look at impoverished life in Detroit. Described as "a work of history in fictional form," it is a multigenerational chronicle of three members of the Wendall family—naïve and gutsy Loretta, charismatic Jules and introspective Maureen—as they struggle to distinguish themselves from a landscape of viciousness and regret.

The Wendall family migrates by bus to Detroit from a midsized midwestern city. They first move to 20th Street, but when their house is slated for demolition, they move to Labrosse Street in Corktown—"closer now to Tiger Stadium and not far from the New York Central railroad terminal, a great gothic building with hundreds of windows." Maureen and Jules's father takes up work on a Chrysler assembly line (a job that won't end well for him). Each family member becomes fixated on work and money, seeking a path to personal freedom. Jules becomes a driver for a low-level gangster. Once a great lover of reading, Maureen comes to use her books to hide cash from her family. Loretta looks jealously upon those who appear to have more than she does, and she crows over those who have less.

As the novel winds its way through mid-century Detroit, the southwest and downtown neighborhoods, as well as the city of Grosse Pointe, take vivid shape. In the afterword to the Modern Library edition of the novel, Oates describes the work as

> a valentine to the Detroit of those vanished years; Detroit at the peak of its economic power, the quintessential American city; the world capital of motor vehicle manufacturing; to its inhabitants, a rhapsody of chemical-red sunsets, hazy-yeasty air, relentless eye-stinging winds; new-constructed expressways cutting through old, settled neighborhoods with the destructive fury of cyclones; overpasses, railroad tracks and shrieking trains, factories and factory smoke, the choppy, usually gunmetal-gray and greasy-looking Detroit River, the daunting length of Woodward Avenue out to Eight Mile Road and Ferndale, the first of the "white" suburbs; wide, littered Gratiot Avenue, Grand River Avenue, John R., Outer Drive, Michigan, Cass, Canfield, Second Avenue, Third Avenue, Highland Park, Jefferson, Vernor, Fort, Jos. Campau, Dequindre, Freud (pronounced exactly the way it looks,

Clock tower on the campus of the University of Detroit–Mercy. *J. Gordon Rodwan.*

"frood"), Beaubien, Brush, Randolph, Livernois, Six Mile, Seven Mile, Fenkell. Fenkell! Such blunt syllables, such spondees, are the very music of this Midwestern city; former inhabitants recite them together like poetry.

Oates taught at the University of Detroit–Mercy from 1962 until 1967. She was the second female faculty member at the school and the first who wasn't a nun. Her office was in the no-nonsense Jane and Walter Briggs Liberal Arts Building, and she taught English classes in the Commerce and Finance Building. "Though I worked quite hard, with four courses each semester at U. of Detroit," she said, "I seem to have budgeted my time carefully, and used every minute for teaching, writing, reading, living. It seems that I have much more time now."

In *Them*, the novel's setup features a narrator who teaches at the same university and resembles Oates—even sharing her name. Oates the narrator receives letters from Maureen Wendall, who is fashioned as a former student who failed her Introduction to Literature class.

Less than fives miles from the university is the intersection of Rosa Parks Boulevard and Clairmont Street. It is the corner where, in July 1967, police raided a blind pig and ignited five days of deadly civil unrest. Whether you call it a riot or a rebellion, it marks the nightmarish finale of *Them*, a cataclysm told largely through the eyes of Jules. "The fires were spreading. People were running up the street with their arms filled with clothes and bedding and kids." Especially unsettling is Oates's portrayal of a particular group of self-satisfied young people as they restlessly linger around Wayne State University's campus in the hot weeks before the raid, heatedly debating arbitrary assassination targets.

It is worth comparing Oates's rendition of July 1967 with Jeffrey Eugenides's *Middlesex*, which, in a major arc, traces a tank that rumbles through city streets: "To live in America, until recently, meant to be far from war…But then why [did I see]…a tank rolling by our front lawn? An armor-plated military vehicle encountering no greater obstacle than a roller skate. The tank rolled past the affluent homes, the gables and turrets and the porte cocheres. It stopped briefly at the stop sign. The gun turret looked both ways, like a driver's ed student, and then the tank went on its way."

Preceding *Them* in the Wonderland Quartet is *Expensive People* (1968), another finalist for the National Book Award. In the fictional Fernwood, a wealthy Detroit suburb in the mid-1960s, Oates verges on the same terrain as *The Weedkiller's Daughter* by Harriette Simpson Arnow. Fernwood—a well-to-do community that is not quite so well-to-do as neighboring Fernwood

Park at the corner of Detroit's Clairmount Street and Rosa Parks Boulevard, the site where five days of unrest began in July 1967. *Nick Hagan.*

Heights—is a place of fresh green lawns, neat houses, a domesticated river and a sunny library with a Browse & Leaf shelf, where residents page through magazines. Streets with names like "Burning Bush" are studded by "enormous stone houses, brick houses, fake Scandinavian houses, English, French, Southwest, Northeast houses, a sprinkling of 'modern' architecture that never manages to look more than nervously aggressive in this conservative environment." As for the metropolis that Fernwood neighbors, it is being "rebuilt," but "no one went down there any more; just a few people who had to work there and misguided tourists."

Expensive People is set up as the memoir of an intellectual eighteen-year-old named Richard Everett, who is feverishly telling the story of how he, at age eleven, came to kill one of his parents. The meta-fictional text, however, casts doubt on the reliability of what the boy tells us. While *Expensive People* has the shine of a suspense novel, it is most powerful in its depiction of the invisibility of children. Partly because this was an era when parent-child relationships were generally more detached and partly because of their character flaws, Richard's parents fail to really see him. "It was the first time that day she had bothered to look at me," Richard tells us at one point. His mother pokes him so that he will stand straighter, even though he is already painfully pulling back his shoulders.

The boy personalizes this invisibility. He describes his breakdown in the days before the fatal gunshot as the period of his "disintegration." At the same time, as an only child with few companions, Richard is overly preoccupied with his father and mother. He spies on their glossy cocktail parties. He eavesdrops through laundry chutes. He haunts the Browse & Leaf shelf so he can look up short stories that his mother has published in magazines.

Expensive People also depicts the empty interchangeability that can be imposed on children. When the family moves from one midwestern suburb to another, the very same people show up as neighbors. When Richard enters a demanding mock-English private school (the hilariously named Johns Behemoth), he is juxtaposed with other boys just like himself: intelligent, neglected, affluent and prone to taking outsized responsibility for their parents' behavior. When he was very young, Richard loved a dog named Spark that was accidentally run over; his parents replaced him with a similar-looking dachshund. Though Richard's senses belied the truth, they told him emphatically that it was the very same Spark.

It is important to note, as *Kirkus Reviews* put it in its 1968 write-up, that *Expensive People* "is not primarily an indictment of suburbia, but a savage exposure of self-orbiting deceptions." A sly absurdist humor is threaded through the text, leavening the gothic tale. Oates once called it the least difficult novel she ever wrote.

But again and again, Oates is drawn to moments of rending violence—or the fear of them—in her fiction. This is where she finds the full potency of what humans reveal and obscure from one another. Her ability to look directly at brutality surprised her early reviewers. In 1969, shortly after the publication of *Them,* Walter Clemons interviewed Oates for the *New York Times* book review. Here is how he described her:

> *She turned out to be a frail, shy-voiced girl with soft, dark eyes—she is so gentle that if you met her at a literary party and failed to catch her name, it might be hard to imagine her reading, much less writing, the unflinching fiction of Joyce Carol Oates.*

A *Newsweek* feature in 1970 cast a similar light:

> *Miss Oates is quiet, almost timorous, spectrally thin, occasionally remote in self-defense when asked questions that invade her carefully guarded inner life…Her diffident, controlled exterior conceals a fiery intensity. Only the pen unleashes it.*

Most memorable was the newspaper headline on a 1965 review of a play that Oates wrote, which was performed in New York City. "Detroit Housewife Writes Play," it read, evoking the prevalent attitude of the time. Eleven years and many books later, a headline in *People* magazine characterized her as a "Shy Faculty Wife." In both cases, the publications neglected that Oates was herself a college professor.

In the meantime, Oates was writing experimental stories like "How I Contemplated the World from the Detroit House of Correction and Began My Life Over Again," where she again turned to the upper-middle-class suburbs of Detroit. First published in 1969, the collage-style tale features an unnamed sixteen-year-old narrator from Bloomfield Hills with a habit of bumming around in Detroit. The girl has a history of shoplifting department store jewelry that she doesn't even like, and her brother was sent away to boarding school in Maine after, it is implied, he got into trouble. The narrator skips school to visit the city, and she falls in with a dangerous crowd. "What are you looking for anyway?" asks one of them. After a series of traumatic events, including being passed around among different men, a police raid arrests the narrator and her new crowd. When her family takes her back home, she is relieved to be back in her pink room on Sioux Drive. Her parents make clear that they will pretend nothing ever happened ("a new start!"). The conceit of the story, in fact, is that the narrator is piecing together notes for an English essay at Baldwin Country Day School about her "revelation of the meaning of life; a happy ending." But the story's fragmented nature leaves readers aware of how much is undone.

Another story, "In the Region of Ice," won the O. Henry Prize for short fiction. It is set at a small Jesuit university resembling the University of Detroit–Mercy and fictionalizes Oates's interaction with a real-life honors student named Richard Wishnetsky. In 1966, at the Shaarey Zedeck synagogue in Southfield, the twenty-three-year-old Wishnetsky murdered the celebrated rabbi Morris Adler, just as the prayer for the dead began at a Sabbath service. Wishnetsky read from a sheet of paper, accusing the congregation of about six hundred worshipers, which included his family, of "phoniness and hypocrisy." He then turned the gun on himself.

In Oates's story, Wishnetsky is reimagined as Allen Weinstein—intelligent, troubled, curious and hungry to form a connection with his English professor, Sister Irene. The nun is "a tall, deft woman in her early thirties," and she is teaching a course on William Shakespeare that Weinstein is enrolled in. "In the Region of Ice" was included in Oates's 1970 collection, *The Wheel*

of Love, and made into a short film directed by Peter Werner, which won an Academy Award for best short subject in 1977.

Oates visited the Wishnetsky murder once more in the title story of *Last Days,* her 1986 collection. This time, the lead character is named Saul Morgenstern:

> *Saul Morgenstern, the Scourge of G-d. His style is outrage tinged with irony and humor...He is a marvelous talker, a tireless spinner of anecdotes, tall tales, moral parables. With enviable agility he climbs the steps to the "sacred" space before the congregation. With a burst of extraordinary energy he hauls himself over a six-foot wall (littered with broken bottles, it is afterward claimed) while his friends stand gaping and staring. He risks death, he defies death, knowing himself immortal. The entire performance is being taped. Not a syllable, not a wince, will be lost. He has penciled in last-minute corrections in his fastidious hand, the manuscript awaits its public, he can hear beforehand the envious remarks of his friends and acquaintances and professors. Am I the Messiah, he wonders, with so many eyes upon me?—standing erect at the lectern, the pistol in one hand and the microphone in the other.*

Oates's fascination with the quiet moments before violence breaks forth continues in the short-story collection *High Crime Area* (2014). Oates sets the title tale on the campus of Wayne State University in April 1967, "months before the explosive uprising." A fretful young woman who teaches composition at Wayne State has taken to carrying a handgun in her pocketbook. Her story begins on a note of paranoia and racial distrust: "One of them is following me. I think it must be the same (male, black) figure I've seen in the past. But I could be mistaken." The story speaks not only to the state of fear that catalyzed the events of July 1967 but also, as Oates explained it, to "a curious sort of bond between the races." The young white instructor is juxtaposed with her former student, a young black man who has been incarcerated. As the two interact on the streets outside campus, they both pretend not to notice the subtext between them. They "are locked in a sort of mutual deception," as Oates described it to me. "At the same time, each is pretending to not quite see the other's perspective."

Oates follows contemporary Detroit from a distance these days. She makes her life in New Jersey, where she teaches at Princeton University. Two close friends from Michigan still live in the city, and "I am very sympathetic with the plight of its citizens," she said. But the Detroit of today is "much changed." When she was last in the city for a book event at the nearby Grosse Pointe War Memorial, she visited Detroit "as a sort of tourist."

But there was a time when Oates was intimately familiar with the streets of Detroit. After moving out of her Palmer Park apartment, she and her husband, Raymond Smith, lived "a year or two" at 2500 Woodstock Drive, a Colonial home on a corner lot, just south of 8 Mile Road, not far from Woodlawn Cemetery. They then moved to 3460 Sherbourne Road, north of 7 Mile. Another Colonial on a corner lot, it had a large front lawn, black shutters and a brick chimney. Ray commuted across the Detroit River to teach English at the University of Windsor in Ontario. In an upstairs room that had once been the bedroom of a child—it had pink walls—there was a desk, a straight-backed chair and a bookcase. This is where Oates wrote

Number 2500 Woodstock Drive in Detroit, where Joyce Carol Oates lived in the early 1960s. *J. Gordon Rodwan.*

Number 3460 Sherbourne Road in Detroit, where Joyce Carol Oates wrote the novel *Them*. *J. Gordon Rodwan.*

Them. "We were very happy in that house on Sherbourne Road," she later wrote. It was her final home in Detroit.

Oates and her husband, along with their Persian cats, moved across the river to Windsor in 1968. They chose a home on Riverside Drive East and remained there for the next decade. From the back terrace, they looked directly across the Detroit River to Belle Isle. Farther up, they could see Grosse Pointe. Oates came to know this horizon well. The writing table in her study faced the river, and she often dreamed through her fiction while lingering out on the lawn.

"Windsor was a fairly cosmopolitan city in those days," Oates said. She remembers the University of Windsor, where she also taught English, as having an especially international faculty and student body. But she has heard that the presence of a casino downtown has altered the city ("Too bad!").

Windsor bookshops did not stock her novels, but she pursued writing with her native passion, even as she kept a full teaching schedule. She loved to write in the mornings, before breakfast, sometimes for long stretches and sometimes for just an hour before hurrying to her first class of the day—a creative writing workshop, or a graduate seminar on modern literature, or an oversized undergraduate lecture. Oates forced herself to begin writing,

no matter what mood she was in, even "when I've been utterly exhausted, when I've felt my soul as thin as a playing card, when nothing has seemed worth enduring for another five minutes…and somehow the activity of writing changes everything."

On a sabbatical year in London, she began the novel *Do with Me What You Will* (1973). She dreamed through the story of love, law and adultery while running through Hyde Park, re-creating the feeling of Detroit's avenues in her imagination. "I was so afflicted with homesickness for America, and for Detroit, I ran compulsively; not as a respite for the intensity of writing, but as a function of writing."

All together, her years in Windsor were "very happy and very productive," Oates told me. "It was a time of ambivalent feelings, when we moved to Princeton." In her final accounting of Detroit, she "found much to love in the city." She and Ray had been "tireless, enthusiastic walkers, hikers, and bicyclists." They often visited friends in Birmingham, Bloomfield Hills and Grosse Pointe. And Detroit proved to be the landscape for the first wave of her literary life.

She has lived on the East Coast since 1978, but Detroit continues to be a well of inspiration. *The Rise of Life on Earth*, a 1991 novel, follows Kathleen Hennessey from childhood to young adulthood in working-class Detroit. *The Sacrifice* (2015) is located in a fictitious New Jersey city in the 1980s "that has endured racial unrest, police violence, and protracted discrimination," Oates said. "Partially, the city is based upon Detroit and partly upon Newark." It was not until after Oates left Detroit—and particularly as she prepared to write *The Sacrifice*—that she became aware of "the shocking degree of police brutality toward African Americans in cities in the U.S. generally, and in Detroit specifically.

"Most white citizens in 1967 had not a glimmer of an idea of the extent of police brutality and corruption in cities like Detroit," she added. "The media did not report these terrible incidents, and overall, there was a kind of amnesia regarding past injustices. Today, there has been some improvement. We have a long way to go before acquiring racial equality and justice, however."

Oates hesitated when asked about her greatest hope for Detroit.

"'Greatest hope for Detroit'—I'm not sure. A restoration of some measure of economic, civil, and cultural stability, of course," she said. "It is such a vast problem, perhaps one ought not to approach it in a simplistic way. There would not be room to adequately discuss this important issue."

Chapter 5
Jim Harrison's True North

Jim Harrison dances among genres—fiction, poetry, essays, screenwriting, memoir, journalism. But the natural world, rich in image and rhythm, is his through line. Rural-born characters, alien to the polished smoothness of civilization, are at the center of Harrison's imaginative universe.

In terms of mainstream publishing and the reviewing media, Michigan itself is something of an alien. When an interviewer for the *Paris Review* asked whether it was a "problem" for him to be a Michigan, or midwestern, writer, he responded:

> *What I hate about this notion of regionalism in literature is that there's no such thing as regional literature. There might be literature with a pronounced regional flavor, but it's either literature on aesthetic grounds or it's not literature. In the view of those on the Eastern Seaboard, everything that is not amorphous, anything that has any peculiarities of geography, is considered regional fiction, whereas if it's from New York, it's evidently supposed to be mainstream. I told my agent...that it struck me that the Upper East Side of New York was constitutionally the most provincial place I'd ever been.*

Harrison was born in Grayling in 1937 to a family who prized literature. His parents read omnivorously: "all of Hemingway and Faulkner and Erskine Caldwell." The Harrisons moved south, to Haslett, outside Lansing, and when Harrison was seven, he quarreled with a neighbor girl, who shoved

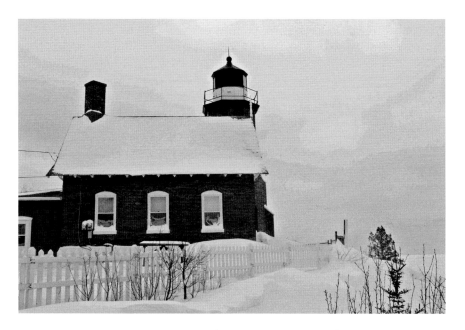

Winter at the Eagle Harbor lighthouse on Michigan's Keweenaw Peninsula. February 2013. *Bethany Helzer.*

a broken bottle in his face. It blinded him in one eye. "I probably wouldn't have been a poet if I hadn't lost my left eye when I was a boy," he said. After the accident, "I retreated to the natural world and never really came back, you know."

After the accident, Harrison's father thought he needed extra attention, so he took him trout fishing. On one of their trips, Harrison asked his father what the difference was between people and animals. "Nothing," his father replied. "They just live outside and we live inside." This struck the boy deeply, attuning him to the schizophrenia of those who speak of nature as something separate from the self.

Harrison had an omnivorous appetite for the world. He rode his bike from Reed City to Charlevoix, more than one hundred miles, and then camped for a week on Beaver Island, "which was fabulous back then, relatively undeveloped." Because he wanted to see the Pacific Ocean, he lied about his age and worked as a bellhop at West Coast resorts. In his late teens, he hitchhiked to New York City with ninety dollars in his pocket. From the *Life* magazines that he read, Harrison figured that the way to be an artist was to move to "Green-witch" Village and live as a bohemian. He packed his favorite books—Rimbaud's *Illuminations* (Louise Varese translation),

Faulkner's *The Sound and the Fury*, *The King James Bible*, Dostoyevsky's *Notes from Underground* and Joyce's *Finnegans Wake*. He towed along the used typewriter he received for his seventeenth birthday. His father gave him a ride to the highway and wished him well.

Harrison graduated from Hastings High School in 1956 and went to college down the road, at Michigan State University. A year before he received his bachelor's degree, Harrison married Linda King. In 1962, when he was twenty-five years old, he waffled on whether to join his father and his nineteen-year-old sister, Judith, on a hunting trip. He decided not to go. A few hours after waving goodbye to them, a drunken driver crashed into his father's car. Both his father and his sister were killed. It left the grief-stricken Harrison thinking, "If this can happen to people, you might as well do what you want—which is to be a writer. Don't compromise at all, because there's no point in it." He wrote the first poem that he felt was "finished" soon after their funeral.

Harrison stayed on at Michigan State, where he met his lifelong friend Thomas McGuane, a Wyandotte native and Cranbrook School alum with whom he shared a passion for writing. Harrison earned his master's degree in comparative literature in 1964. With help from a chance connection that he made while visiting his brother in Boston, Harrison published his first collection of poems, *Plain Song*, a year later. ("A promising talent," *Kirkus Reviews* proclaimed.) The book gave Harrison the opportunity to teach modern poetics at the State University of New York–Stony Brook, but he did not take well to teaching. With the help of fellowships from the National Endowment of the Arts and the Guggenheim Foundation, he quit after one year. He has been a full-time writer ever since, making ends meet by picking up freelance screenwriting and manual labor gigs.

"I'd think, I want to be like Lord Byron or Vincent van Gogh," Harrison said. "And then I'd realize, how can a boy from a little farm town do that?" But the years he spent as a laborer—block layer, carpenter, well-pits digger— taught him endurance. Long hours at repetitive tasks gave him the patience of sitting with his own thoughts: to meditate, dream, think.

Harrison lived for decades in a small farmhouse in Michigan's Leelanau County, where he and his wife raised two daughters. He wrote from a converted granary about one hundred yards back from the house. Cheap indoor/outdoor carpet was spread out on the cool floor. A talismanic mobile danced above his writing desk, including a crow's wing, a toy pig his daughter gave him and a pine cone from the forest where Spanish poet Federico Garcia Lorca was executed.

His wife, Linda, grew flowers and vegetables in a large garden. He planted aspen hybrids. They took thousands of walks. "Looking at the Manitous on a winter walk is worth any self-help book save the Bible," Harrison wrote of the Manitou Islands. Inside his home, dogs and cats lolled about while merry friends, passionate about cooking, joined him and his wife to plan, prepare and eat extraordinary meals. Enticing bookcases lined the walls. Outside, a sign warned away stray fans: "Do Not Enter This Driveway Unless You Have Called First. This Means You."

Intimidating signs notwithstanding, Harrison could be goofy. He was known to dance a half hour each day to Mexican reggae music while carrying fifteen-pound dumbbells. His wife used to point out to him that it was when he lost his sense of play that he got into trouble.

A writer for the *Paris Review* (who called ahead) visited the Leelanau farmhouse for five days in October 1986. In his introduction to the published conversation, the writer described Harrison's full-hearted character and the landscape that shaped him.

> *Harrison is a man of prodigious memory and free-wheeling* [sic] *brilliance and erudition, as well as great spirit and generosity, lightness and humor; so the reader should imagine wild giggles and laughter throughout, and supply them even when they seem inappropriate—especially when they seem inappropriate. Imagine, too, the sounds and the textures in the background of the tapes: the easy talk of friends and hunting cronies; the light, cold drizzle of the wettest fall in Michigan history; sodden leaves and branches underfoot; and always the ringing of the dogs' bells, sometimes nearby, sometimes barely discernible, fading into the woods.*

Harrison also had a small cabin near Grand Marais in the Upper Peninsula, near the Sucker River. He purchased it with an early royalty check. Friends joined him there to hunt woodcock and grouse. He saw bears almost daily, and he walked the Kingston Plains, a stretch of land filled with the weathered stumps of once-majestic trees. When worn out by the remoteness of the cabin, Harrison enjoyed the Dunes Saloon in Grand Marais or the Landmark Hotel in Marquette, where the room he usually stayed in is now dubbed the Jim Harrison Suite.

Harrison has the soul of a poet. He did not write a novel until 1971, when he was recuperating after falling off a cliff while bird hunting. The accident put him in traction for a month, and he was bedridden for much longer. His friend McGuane, who had just published his second novel, *The Bushwacked*

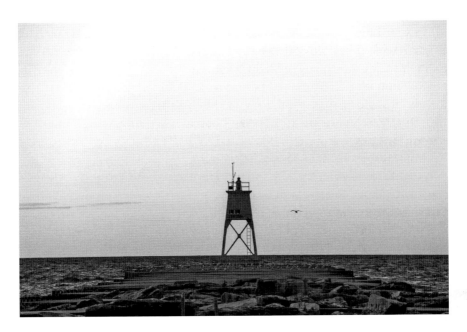

The Grand Marais lighthouse on Michigan's Upper Peninsula. September 2013. *Bethany Helzer.*

Piano, suggested that a lengthy work of fiction might be just the thing to while away his time.

Harrison started out by diagramming the novel: all in pictures, no words. When he got around to typing, he opened the first chapter with a two-page sentence. "It was a vain decision. I wanted to show it could be done. I was a young writer, and hungry." The novel, titled *Wolf: A False Memoir*, is the fictional life story of a man named Swanson who leaves his life of debauchery in Manhattan for the Huron Mountains west of Marquette in Michigan's Upper Peninsula. Brimming with anger and heartbreak, Swanson wanders through looming trees, looking for rare wolves in the wild.

Harrison mailed off his only copy of the manuscript to a publisher. But it got caught in limbo: the manuscript was lost for a month somewhere between Michigan and New York during a postal strike. It eventually made it through, and the editors welcomed it. "When they accepted it for publication I was somewhat surprised. I thought, 'Oh good, here's something else I can do.'"

Writing a novel hooked Harrison. He soon wrote *A Good Way to Die* (1973), which he described as "the first Vietnam book," and *Farmer* (1976), about a middle-aged man named Joseph who must choose between his lovers and whether to stay in rural Michigan or seek a new life elsewhere.

"An idea that fixed him in one spot was that life was a death dance and that he had quickly passed through the spring and summer of his life and was half way through the fall. He had to do a better job on the fall because everyone on earth knew what the winter was like." The uncertainty disorients Joseph, even in his familiar woods. "Joseph tried to imagine a time when Michigan wasn't a game farm for hunters, when the natural predators, the puma, the wolf, coyote, and lynx still lived there. And the Indian. Not man hunting for sport and his house pets gone wild and utterly destructive. But the wave passed..."

Farmer did not do well in sales, however. Harrison felt that it was poorly promoted by the publisher, but whatever the reason, he was heartbroken. It did not help that Harrison was struggling with his drinking at the time. Money was a horror show; the first seventeen years of his marriage, he and his wife averaged less than $10,000 a year. He did not pay taxes for five years, and when his eldest daughter won a full scholarship to college, he could not fill out the acceptance forms because he had no IRS returns to prove what they made. When Harrison wrote *Letters to Yesenin* (1973)—a book of intimate conversational poems written in the form of letters to a Russian poet who committed suicide at age thirty—he wrestled seriously with the itch to end his own life.

> *I don't have any medals. I feel their lack*
> *of weight on my chest. Years ago I was ambitious.*
> *But now it is clear that nothing will happen.*
> *All those poems that made me soar along a foot*
> *from the ground are not so much forgotten as never*
> *read in the first place. They rolled like moons*
> *of light into a puddle and were drowned. Not even*
> *the puddle can be located now. Yet I am encouraged*
> *by the way you hanged yourself, telling me that such*
> *things don't matter...*

But he comes out in the book disavowing suicide, at least as an option for himself.

> *...Beauty takes my courage*
> *away this cold autumn evening. My year-old daughter's red*
> *robe hangs from the doorknob shouting* Stop.

Life-affirming resolve, however, does not make money problems disappear. Harrison was hoodwinked out of payments for his screenplays, and the checks were the only reasons he was writing them in the first place. "The reason why writers go out to Hollywood is to get some money. Which I still found preferable to teaching. If I can write a screenplay in two months and it pays what I would earn teaching for a year and a half, why not?" Harrison was offered jobs in creative writing departments over the years: high-paying posts that required little work in exchange for the department being able to promote his name on its faculty list. He always turned them down—even one that promised $75,000 in a year that the Harrisons made $9,000. "Somebody's got to stay outside," he told them.

It was the actor Jack Nicholson, of all people, who helped pull Harrison out of the hole. The two men met on the set of the 1976 film *The Missouri Breaks*; Nicholson starred in it, and Harrison's buddy McGuane wrote the script. They got on well, and when Nicholson asked to read something by Harrison, he was handed a copy of *Wolf*. He liked it and told Harrison to call him up if ever he had an idea for him. Harrison never called—"I wasn't even sure what he meant"—but a year later in Los Angeles, they met up and went to a movie together. "It was really pleasant, and I was impressed with his interest in every art form." When the actor learned that Harrison was broke, "he rigged up a deal so that I could finish the book I had started, which was *Legends of the Fall*."

Harrison finished *Legends*, his first suite of novellas, in 1979, when he was thirty-seven years old. Hollywood bought all three of the tales, which, along with more paychecks for his screenplays, brought the Harrisons their first real money. He did not know what to do with it, and aside from buying a Suburu car, he "pissed it away, high living and loaning it."

The title tale of *Legends*, based on journals kept by his wife's grandfather, is a fifteen-thousand-word story spanning nearly half a century in the lives of a father and three sons in the northern Rocky Mountains. Harrison wrote it in nine days, much of it at a lodge on Lake Michigan near his Leelanau farm. "But that's the only time it ever happened that well. It was like taking dictation…but it was after I'd thought about the story for five years." When he finished, he was exhausted, overwhelmed. But it was done. *Esquire* published the novella in its entirety, a fantastical prospect nowadays. When it was adapted into the acclaimed 1994 film, Harrison had a writing credit. Not long after, Nicholson starred in *Wolf*, co-written by Harrison—though it is hardly an adaptation of Harrison's passionate first novel. Instead it is a romantic-horror film directed by

Windmill and sunset in Grand Marais in Michigan's Upper Peninsula, near the Coast Guard station at the pier. August 2005. *Geoff George.*

Mike Nichols with Nicholson portraying a publishing house editor who becomes a werewolf.

Another book of novellas, *A Woman Lit by Fireflies* (1990), introduces the character of Brown Dog. Called B.D., he is a creature of the Upper Peninsula, an impulsive man of Chippewa and Finnish descent, an expert trout fisherman, a "kindly fool," a bawdy itinerant worker with a limitless passion for women who drinks too much; in fact, he favors the same Dunes Saloon in Grand Marais that Harrison does. B.D. was raised by his grandfather and prefers to sleep in the cool outdoors. With humor and pathos, his misadventures dramatize his effort to figure out what matters in a changing world.

In his debut, the novella called *Brown Dog*, he discovers the body of an Indian chief frozen in the dark depths of Lake Superior, perfectly preserved in ice. "What few people know is that Lake Superior stays so cold near the bottom that drowned bodies never make it to the surface." The idea came to Harrison after visiting the Great Lakes Shipwreck Museum at Whitefish Point, which exhibited photos of a galley cook in a ship that sunk in the 1890s. The cook floated in the galley, looking almost human, except that he did not have eyes. Neither does the chief in Brown Dog's story. While the

character mulls over what to do with the body, a team of anthropologists from the University of Michigan tries to manipulate him into showing them an ancient Hopewell burial ground that they want to dig up. In later stories, B.D. finds himself on the tour bus of a band, road-tripping to Montana, and becoming a loving foster parent to two children, including one who suffers from fetal alcohol syndrome. The Brown Dog tales are collected in a 2014 omnibus bearing the character's name as the title.

Harrison stretched the thread of the Brown Dog story over more than two decades. He knit together his imaginative universe in other tales, too. Characters in his celebrated novel *Dalva* (1988), set in the Sand Hills of Nebraska, also appear in *The Road Home* (1998). The novel *True North* (2004) focuses on a timber and mining family whose wealth came from the decimation of the majestic white pine wilderness of Northern Michigan. It was inspired by a walk Harrison took with a friend through the Kingston Plains, when they both agreed that they were glad their grandfathers were not responsible for such devastation.

The father in *True North* is a cruel alcoholic; the mother numbs herself with pills. "When Father was there he shook their martinis in a silver lidded container over his shoulder as if he were creating a masterpiece or a ritual without which polite society could not healthily proceed." David Burkett, the book's protagonist, is seeking a way to atone for his family's sins, while

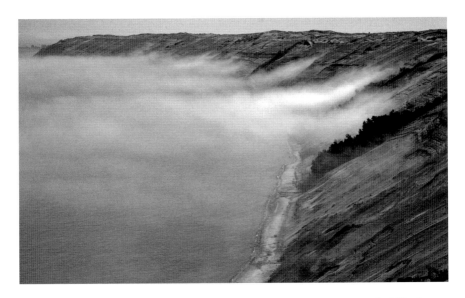

Fog on the Grand Sable Dunes on Lake Superior. In logging days, loggers rolled fifty-foot-long tree trunks down these high dunes. August 2005. *Geoff George.*

his sister, Cynthia, and his lapsed-priest uncle find relief in "outsider" communities, particularly among the Upper Peninsula's Indians. David's search for a way to live an honest life is juxtaposed against cultural pressure for people to turn their lives into myths—something symbolic of what is good and worthy rather than something that is *actually* good and worthy.

Returning to Earth (2007) is set thirty years later in the same Upper Peninsula woods. Donald, the Finnish-Chippewa youth who romances Cynthia in *True North*, is now middle-aged and dying of Lou Gehrig's disease. By turns, different narrators take over the story, including David, who has grown up to be an eccentric man dedicated to humanitarian work on the Mexican border. It is a sentimental novel, partly inspired by the death of Harrison's brother John, the one he visited in Boston before his first book of poems was published.

The numerous books of fiction and poetry that Harrison has published over the last twenty years are the product of a late-career burst of activity. They are looser and more languorous than his earlier work, more uneven and flawed but also exuberant and poetic. They were pounded into life, not so much with inspiration but by hard work. Harrison puts in hours at his writing desk every morning and sometimes afternoons, often starting the day by working on a poem before shifting to prose. He thinks through his stories before writing a single word, percolating with them for a year or more, because he found it too discouraging to try to write without knowing what he wanted to say—"dog-paddling," he called it. Long bouts of brooding over stories happen when Harrison is walking or driving. One year, he drove twelve thousand miles around the United States. "I'll take long, directionless car trips to try and see where my mind is. Usually, the story begins with a collection of images. I'll make a few notes in my journal, but not very much. Often not much more than a vague outline. A tracery, a silhouette."

After his day's writing, he sometimes spends the afternoon hunting quail, doves and grouse. He does not hunt mammals, as a rule, after an unhappy experience deer hunting as a child, and anyway, the hunt is more about the walk and the pleasure these days: "just to stay alive, because writers die from their lifestyle but also from their lack of movement."

Harrison is sometimes categorized, along with Ernest Hemingway, as a "macho" writer—one who glorifies a sort of rugged, boastful, violent ethic. The *Paris Review* asked Harrison about this perception, which the writer dismissed.

All I have to say about that macho thing goes back to the idea that my characters aren't from the urban dream-coasts. A man is not a foreman on a dam project because he wants to be macho. That's his job, a job he's evolved

into. A man isn't a pilot for that reason either—he's fascinated by airplanes. A farmer wants to farm. But you know what it's like here and up in the Upper Peninsula. This is where I grew up. How is it macho that I like to hunt and fish? I've been doing it since I was four.

When Tom Bissell, a writer from Escanaba, profiled Harrison in 2011 for *Outside* magazine, he took up the notorious Hemingway comparison:

[Harrison] *still resents the comparison, he told me, "because there's no connection whatsoever" between his and Hemingway's work. For what it's worth, I agree with Harrison, whose large, ecstatic voice is more indebted to Joyce, Faulkner, Nabokov, and García Márquez. But Harrison writes of hunting and fishing and Michigan, as did Hemingway: for critics who neither hunt nor fish nor know Michigan from Minnesota, these are literary doppels that gänger. "In my lifetime," Harrison told me, "the country has gone from being 25 percent urban and 75 percent rural to 75 percent urban and 25 percent rural." A critic from a major American magazine once asked Harrison if he had ever personally known a Native American.*

After a lifetime of writing, fishing and living in Michigan, in 2002 Harrison and his wife moved to Montana, where their daughters and grandchildren live. His family visited Montana every year since he went on a trout-fishing trip in 1968 with McGuane. Just as many people move to Northern Michigan after happily vacationing there in their youth, so the Harrison daughters moved west. "Readers might be careful where they take their children on vacations if they're unsure they wish to end up there," Harrison wrote in his farewell note to Michigan.

The Harrisons live on a gravel road just outside Livingston. They wait out the cold of winter in Patagonia, Arizona. Few in Arizona have traveled to Michigan. "I tell visitors what it's like being on Lake Superior and just pulling over to drink the water, because there's no industries for a hundred miles until way over to the Soo," Harrison explained to Jerry Dennis, a writer who lives near Traverse City. "There are those 50 or 60 miles of deserted beach I could walk, watch ravens arguing over a dead fish."

Before he left the state, Harrison filled two Ziploc bags: one with bark from a birch tree and one with sand from Lake Superior's shore. They sit on his writing desk, as talismans.

Chapter 6
The Waking

Theodore Roethke

When the *Atlantic* asked Jim Harrison to share a favorite literary passage in 2014, he chose a poem called "I Knew a Woman" by Theodore Roethke. Its elemental rhythm reveals the power of language to go beyond intellect and become music—a kind of invocation.

> *I knew a woman, lovely in her bones,*
> *When small birds sighed, she would sigh back at them;*
> *Ah, when she moved, she moved more ways than one:*
> *The shapes a bright container can contain!*
> *Of her choice virtues only gods should speak,*
> *Or English poets who grew up on Greek*
> *(I'd have them sing in chorus, cheek to cheek).*

"I read Theodore Roethke very early on because he was, like me, from Michigan," Harrison told the magazine. "He lived in a big greenhouse that was owned by his father. He was a great big fellow—sort of a tosspot, if you know what I mean. Probably should have lasted longer than he did. But he was a marvelous poet."

Roethke was born in 1908 in Saginaw. This fertile, flat country was one of the farthest points west that French writer Alexis de Toqueville traveled to on his famed 1831 journey to discover the essence of a young American country. In de Toqueville's journals, he describes the Saginaw River as nearly hidden by prairie grass. The city was no more than a handful of log

houses built for fur traders; it had not yet become a nexus of the lumber industry. After de Toqueville spent a day duck hunting along the river with his traveling partner and French Canadian guide, he described his feeling for the place: "We become more circumspect. We see humming-birds [*sic*] for the first time. A storm that day. Beautiful sight. Calm preceding it. Buzzing of insects, bursts of thunder, its almost endless echo in the solitudes that surround us."

At the turn of the century, the emerging automobile industry supply chain took root in Saginaw. Wealth from the lumber boom led to the construction of gracious houses. Three years after Roethke's birth, his father, Otto, and his mother, Helen, moved into a frame house at 1805 Gratiot Avenue. Otto's brother Charlie lived in the fieldstone house next door. Together, the brothers owned the William Roethke Floral Company, founded by their father, a Prussian immigrant. As a boy, Roethke spent long hours in the enormous greenhouses that stood on twenty-five acres behind his house: a "garden in a machine." Farther out in the country, the company held the last stand of virgin timber in the Saginaw Valley (mostly walnut and oak) and a wild area of second-growth trees that Otto and Charlie turned into a small game preserve. One of Roethke's earliest memories was watching herons

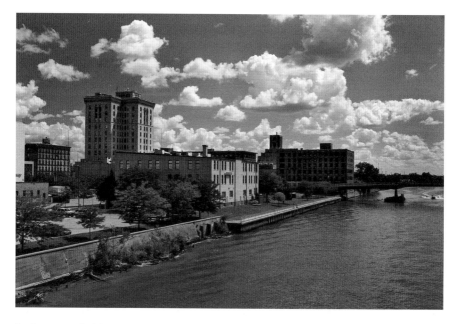

Saginaw, on a bright summer day. Tallest structure is the Citizens Bank Building. July 2006. *Geoff George.*

nest in a swampy part of the preserve. "As a child, then, I had several worlds to live, which I felt were mine," Roethke said in a BBC broadcast.

Roethke's mother insisted that he strive for perfection in all things and that he be a gentleman, but beyond that, he was let alone. He hung around Michigan Avenue with immigrant kids from Russian and Polish families and attended Sunday school at the Presbyterian church with his sister June. He took dancing lessons at the Masonic Temple and piano lessons with a lively woman named Mrs. Emma Martin. He helped with his father's work with the plant life; roses and orchids were the company specialties. The greenhouse—a steamy simulacrum of the tropics standing against Michigan's mercurial weather—became "my symbol for the whole of life, a womb, a heaven-on-earth."

Roethke was a hard-reading and hardworking student at John Moore Elementary School, which, because of its large population of German immigrants, allotted an hour a day for German-language studies. As a freshman at Arthur Hill High School, Roethke wrote a speech for the Junior Red Cross that was published in twenty-six languages. "I began, like a child, with small things. I really wanted, at 15 and 16, to write a beautiful, a 'chiseled' prose as it was called in those days," Roethke wrote about himself in *Twentieth Century Authors*.

But he struggled with feelings of abandonment, which led to desperation to prove himself. When he was fourteen, a series of tragedies struck his family. In October 1922, Otto and Charlie argued, leading to the sale of the greenhouses. In February 1923, Charlie committed suicide. Otto, ill with cancer, died two months later.

It was a staggering loss. To cope, Roethke assumed a tough-guy image. Fascinated by gangster stories—this was in the early Prohibition years—he bought double-breasted suits and a $400 fur coat. He told unlikely tales about his acquaintance with the underworld. But his real life looked more ordinary. In 1925, Roethke got a job at a pickle factory, where he worked the following six summers, and he moved to Ann Arbor to attend the University of Michigan. By then, Roethke was a lumbering six foot three and weighed 225 pounds, though he was also an intensely competitive tennis player. He was serious about his writing, too. It irked him when he failed to get A's in his English courses. In a "self-analysis" he wrote for a sophomore-year class assignment, he declared that "I write only what I believe to be the absolute truth…In this respect I feel far superior to those glib people in my classes who often garner better grades than I do. They are so often pitiful frauds—artificial—insincere. They have a line that works. They do not write from the depths of their hearts."

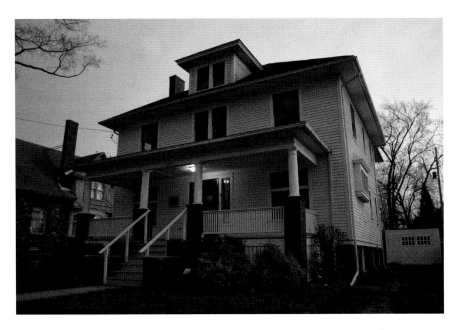

Number 1805 Gratiot Avenue in Saginaw, where Theodore Roethke grew up. It now houses the Theodore Roethke Home Museum. Fall 2014. *Kevin Robishaw.*

Roethke earned his bachelor's degree in English from Michigan, magna cum laude, and to please his family, he enrolled in law school. But he dropped out after a single semester. "I didn't wish to become a defender of property or a corporation lawyer as all my cousins on one side of the family had done." He turned to graduate work in English, spending the 1930–31 academic year at Harvard, intending to earn a PhD. But he never finished because of money difficulties. One significant connection came out of his year in Boston, though: he found a mentor in poet Robert Hillyer. He approached the distinguished Hillyer on Harvard Yard and blurted, "Pardon me, sir. I think I have some poems you might like." A look of pain slid over Hillyer's face, but he politely told the eager young man to come to his office at 11:00 a.m. Roethke did so—complete with fur coat and fancy suit. Hillyer read three of Roethke's poems and, after an interminable silence, he wheeled around in his chair. "Any editor who wouldn't buy these is a fool!" he declared.

With the Great Depression gathering steam, Roethke needed work. He accepted a job at Lafayette College in Easton, Pennsylvania, where he taught and coached tennis for four years. He met the young poet Louise Bogan, who became a great friend, and poet Stanley Kunitz, who became his champion.

In a 1963 essay for the *New York Review of Books*, Kunitz remembered the impression that Roethke made in Easton:

> *My recollection is of a traditionally battered jalopy from which a perfectly tremendous raccoon coat emerged, with my first book of poems tucked under its left paw. The introductory mumble that followed could be construed as a compliment. Then he stood, embarrassed and inarticulate, in my doorway, waiting to gauge the extent of my hospitality. The image that never left me was of a blond, smooth, shambling giant, irrevocably Teutonic, with a cold pudding of a face, somehow contradicted by the sullen downturn of the mouth and the pale furious eyes. He had come to talk about poetry, and we did talk vehemently all through the night. There were times, in the years that followed, when I could swear that I hadn't been to bed since.*

Kunitz and Roethke's favorite game was to try and stump each other on their knowledge of old poets by reading obscure poems aloud and seeing if the other could name the author or date. "We became so adept at the game that we were scarcely ever more than ten years off," Kunitz wrote.

Roethke returned to Michigan in the fall of 1935 to teach in East Lansing at Michigan State College (now University). But he began drinking more than usual, and his behavior became erratic. One cold November night, he walked coatless through the soft woods around Michigan State and had what he described as a "mystical experience with a tree" that revealed "the secret of [dancer Vaslov] Nijinsky." He took off one of his boots to stimulate circulation and then limped several more miles in the blowing wind before hitching a ride back to East Lansing. At home, he took a long hot bath, easing the chill from his skin. The next morning, he skipped his 8:00 a.m. class because he wanted to see how long students would wait around the classroom. It occurred to him that he might visit his dean to explain the reasoning behind the supposed experiment. So Roethke tramped out the door, walking to the dean's office on a circuitous country route, again without a coat. By the time he arrived, he was "so cold and chilled and frightened that I was delirious." The administrator's office called an ambulance for him. A doctor guided the groggy man to its metal door.

Roethke voluntarily committed himself to Mercywood Hospital in Ann Arbor, a psychiatric asylum on Jackson Road operated by the Sisters of Mercy. He remained there for two months. He lost his teaching job. The stay at Mercywood was not easy—at one point, he barricaded himself behind a mattress, naked, refusing medication. Being abruptly cut off from

the alcohol on which he had become dependent made his body spasm and ache. Nearly half a century later, Thomas Lynch, the acclaimed writer from Milford, Michigan, wrote a long poem called "Learning Gravity" about Roethke's time in the sanitarium:

> *Consider Roethke in his tub at Mercywood,*
> *crazy with his glad mayhem, how he would*
> *soak for hours like a length of bogwood...*

Manic-depression, misdiagnosed for years as hypomania and schizophrenia, chased Roethke for the rest of his life. Bouts with it embarrassed him and threatened his ability to work in academia. But he was able to use the episodes to strengthen his artistic resolve and "reach a new level of reality." As Kunitz remembered, "he could brag of belonging to the brotherhood of mad poets that includes William Blake, John Clare and Christopher Smart with whom he identified himself as 'lost.'"

Roethke pieced his life back together. He returned to Saginaw to recuperate and then finished his master's degree in English at the University of Michigan in 1936; he just barely missed passing Robert Hayden in the corridors of Angell Hall. Roethke accepted a teaching position at Pennsylvania State University, and his poetry was published in increasingly prominent publications: the *Saturday Review,* the *New Republic, Poetry.* In State College, he became a skilled teacher. One of his best Penn State students, poet David Wagoner, remembered him in a 2013 interview with the Friends of Theodore Roethke Foundation. Until Wagoner entered Roethke's workshop, "I hadn't given much thought to revising. I was only interested in what I might write next. He urged his classes to demand more of themselves, to keep improving their work and to read, read, read the bulk of poetry written in English, and I've been doing both since."

Wagoner proved his dedication to Roethke by editing his 272 private notebooks into the book *Straw for the Fire* (1972). He also wrote the play *First Class* (2007) about Roethke, "the most charismatic man I've ever met." The one-man show re-creates the spirit of his writing workshops. "The world needs all the good poems it can get!" the Roethke character thunders.

Roethke, incidentally, was not the only teacher in his family. His sister June, who lived in their childhood home on Gratiot Avenue all her life, taught ninth grade English at South Middle School. She made a point of expecting her students to master her brother's poetry. She knew the poems

quite well herself; her brother often asked her to type them for him, since he never learned to handle a typewriter.

Roethke invited celebrated poet William Carlos Williams to give a reading at Penn State in 1940. Williams was fifty-five years old, and his *Complete Collected Poems* was recently published, but he was new to the reading circuit. Roethke, at age thirty-one, had not yet published his first book. His magazine poems were quite different from Williams's plain-speech lyricism: Roethke had a more tightly wound approach to language, feeling that elements like meter and rhyme provided crucial structure for a poem. When the reading was arranged for a Sunday in May, Roethke took the opportunity to treat Williams and his wife to a steak and trimmings, along with a rich Chambertin wine that got Williams tipsy. The writers had a heated debate about poetic form. Roethke followed up by sending Williams a poem he'd written in the formal style that Williams eschewed: "Ballad of a Clairvoyant Widow." ("I see a banker's mansion with twenty wood-gate fires; / Alone, his wife is grieving for what her heart desires.")

Williams responded in a June 30 letter:

> Dear Roethke:
> I like people who carry out their threats, you said you'd send me a poem written in the ballad form and you did send it and here it is and I have read it and it's good.
> HOWEVER.

Williams goes on to critique the poem, arguing that its effect is diminished by the ballad form: the song-style rhythm and rhyme. But he also tells Roethke to "go on writing good poems and prove to me that I'm cockeyed." Perhaps it was because of their stylistic differences—his sense that he needed a counterbalance for his austere sensibility—but Roethke latched on to Williams as a mentor, mailing him his poems for years, along with grateful packages of smoked fish and cheeses. In contemplative letters, Williams pushed Roethke to realize the potential of his authentic voice, in part by localizing his poems or drilling down to the particular geography and culture of a place.

Open House, Roethke's first collection of poems, was published in 1941. The title came as a suggestion from his old friend Stanley Kunitz. The book has imaginative daring and a pronounced personal focus, if it is at times too abstract. Poems are crafted in formal styles, with each syllable carefully measured. They are attentive to nature, from elm trees to barley fields to

horizons that "have no strangeness to the eye / Our feet are sometimes level with the sky." *Open House* won acclaim from the *New Yorker,* the *Atlantic* and other major magazines.

Roethke left State College to teach at Bennington College for a number of years, and then he spent most of 1946 on a Guggenheim fellowship, working on his poetry. He was also recovering from an intense manic episode he had suffered the previous year; for the first time, he had been given shock treatment. By the fall of 1947, Roethke was ready to join the faculty of the University of Washington. He quickly warmed to Seattle. He was a regular at the Blue Moon Tavern, a west-side bar popular with the creative set. In the wide wooden booths, Roethke had a habit of drinking too much while leading passionate informal symposia on the meaning of art and life. On campus, he was a tremendous influence on an entire generation of Pacific Northwest poets. He was a mentor to talent like Carolyn Kizer, Tess Gallagher, Jack Gilbert and James Wright. He helped his Penn State protégée David Wagoner get a job teaching at Washington.

Roethke's courses were always open to the public, which meant that a cross-section of adults found their way to his classroom: everyone from eager eighteen-year-olds to rabbis to sea captains. In the preface to Roethke's selected prose, Kizer wrote, "There was an atmosphere in that classroom that was unlike anything I've ever come across." Roethke gave students lists of verbs from seventeenth-century poets and asked them, "How many of these can you incorporate in a poem?" He advised students to take all adjectives out of their poems to see what they had left, and if a poem felt too loose, he suggested that students force themselves to delete a line from each stanza. He teased students if they imitated his own poems, and he encouraged their own eccentricities. From the beginning of the semester to the end, Roethke championed the memorization of great poems because "they will help you with your work [and] they will help you get through the dry times of life." And if a poetic technique came easily to a student—images, say, or rhyme—he pushed them to work against it, lest they depend too much on a single trick. "Any fool can cut a bad line," Roethke told his students. "It takes a real pro to cut a good line." What is essential to a poem? Not only was this question at the center of Roethke's teaching, but it was also the fire behind his art.

For a poet so influenced by the natural world, the volcanic Pacific landscape, riddled with mountains and thick forests, energized his work. It put his Michigan life in a grander continental context. He knit the pastoral Midwest into poems he wrote about the Northwest landscape, keeping an eye

on "the first trembling of a Michigan brook in April." In Roethke's second book, *The Lost Son and Other Poems* (1948), he returns to the greenhouses of his Saginaw childhood. Organic life textures his writing. He traveled back to Michigan several times to gather detail and atmosphere for the manuscript. Fourteen opening verses turn on the "glasshouse" as a metaphor for the inward and outward tension of modern life. The poem "Big Wind" recalls an extraordinary Saginaw storm:

> *Where were the greenhouses going,*
> *Lunging into the lashing*
> *Wind driving water*
> *So far down the river*
> *All the faucets stopped?—*

At the same time, Roethke wrestles with his stern German American father in poems like "Old Florist" and "My Papa's Waltz." In the latter, jumpy childlike rhythm contrasts with the moody edge of the words:

> *The whiskey on your breath*
> *Could make a small boy dizzy;*
> *But I hung on like death:*
> *Such waltzing was not easy.*

The long title poem of *The Lost Son* pushes the emotional crisis between father and son further. It opens in the Saginaw cemetery where Otto was buried and shifts into an extended poetic sequence, full of intuitive transitions and surprising juxtapositions. *The Lost Son* proved that Roethke was not content to simply repeat poetic tricks that had served him well in *Open House*; he was an agile enough writer to drive his poetry in multiple directions.

"His poems become what they love," Kunitz wrote. "No other modern poet seems so directly tuned to the natural universe; his disturbance was in being human…This florist's son never really departed from the moist, fecund world of his father's Saginaw greenhouses, reputed to be the grandest in the state of Michigan."

Living as far from his boyhood home as he ever had, Roethke also rediscovered the exultant voice of youth. *Praise to the End!* (1953) is his celebration of childhood innocence, a time of unaffectedness and spontaneity. He integrates everything from nonsense lyrics to the rhythm of nursery rhymes in these poems. In "Unfold! Unfold!" Roethke writes about

searching for a "bird no one knows" on the jack pine plains of Northern Michigan—a bird that, while unnamed, is understood to be the endangered Kirtland's warbler. Roethke's boundless love of nature was infused with romance and melancholy. He was concerned about what we lose when we are casual consumers of our landscape and local history.

This was an unfashionable point of view during the flush postwar economy, a time when Michigan's automobile industry was on the throne of worldwide power. But Roethke's barbed lamentations for the degradation of the Midwest's rich natural resources foreshadow the pointed prose and poetry of Jim Harrison. In "Highway: Michigan," Roethke wrote about traffic and how drivers pretend to be masters of their cars when in fact they are subjugated by them. In an unfinished companion poem called "Suburbia: Michigan," Roethke wrote what amounts to be a eulogy for land devastated by those who "live by objects":

> *Bulldozers leveled the curving hillside*
> ------------------------------
> *Tourists stare at an absolute marvel:*
> *A monarch pine, saved by quixotic fancy.*

The monarch pine is a real one. It was a famous tree that stood in Hartwick Pines State Park, north of Grayling, in an extremely rare old-growth forest of pines and hemlocks that survived the heyday of Michigan's timber industry. In 1992, the monarch pine's top was shorn in a storm, and it died four years later. It was believed to be 325 years old.

In 1952, Roethke married Beatrice O'Connell, a young woman who had been his student at Bennington College. They happened to run into each other on the street in New York City one day, and Beatrice asked if he remembered her. Roethke asked for her phone number. Beatrice, without saying her name, told him that it was in the phone book—a test to see if he really knew who she was. He did, and he called her. Though he was seventeen years her senior, they married a month later, with poets W.H. Auden and Louise Bogan as attendants. "Marrying so quickly was rash, but that's what we did," Beatrice told *MLive* in 2011. Before their wedding day, Roethke warned Beatrice about his health problems—the alcohol, the pills, the hospitalizations that could stretch for three months at a time—"but it was very much a life I liked, despite the breakdowns," she said. It is Beatrice who inspired a rush of celebrated love poems by Roethke, including "I Knew a Woman."

The newlyweds traveled for two months in the spring to Ischia, off the coast of Italy, where Auden lent them his villa. Roethke worked on the proofs of his next poetry collection, *The Waking: Poems 1933–1953*. The title poem is shaped in the complex pattern of a villanelle, embodying both the elegance and fire of formalism.

> *I wake to sleep, and take my waking slow.*
> *I feel my fate in what I cannot fear.*
> *I learn by going where I have to go.*

The Waking won the Pulitzer Prize in 1954.

For the next two years, Roethke and his wife traveled to Europe on a Fulbright grant. They lived in an apartment in a new building in Florence, at the edge of the Ponte Vecchio, which was one of the few places in Italy that had been bombed during World War II. Roethke's writing had developed to the point where it was excitedly received by the literary world. He won two National Book Awards, first for *Words for the Wind* (1957) and then for *The Far Field* (1964). He picked up the Bollingen Prize, the Edna St. Vincent Millay Prize and many other honors. The Ford Foundation gave him a grant for reading tours in New York City and Europe. Roethke had become a man at the pinnacle of the intellectual life of his time. Delmore Schwartz searched for language to describe why Roethke's work was so fascinating to so many people in his review of *Words for the Wind*: "These poems appear, at first glance, to be uncontrollable and subliminal outcries, the voices of roots, stones, leaves, logs, small birds; and they also resemble the songs in Shakespearian plays…Roethke uses a variety of devices with the utmost cunning and craft to bring the unconsciousness to the surface of articulate expression."

Back in Washington, Roethke often visited Prentice and Virginia Bloedel, good friends who lived not far from the studio cabin he and Beatrice shared on Bainbridge Island in the Puget Sound, five miles west of Seattle. (The Roethkes also had a home in the city, one with a large porch that was a favorite for parties.) The Bloedels made tremendous wealth in the timber industry, and their home was not an ordinary one. It was a 150-acre estate on the north end of the island, where lawns, pools and clutches of trees were landscaped into a precise and pleasing pattern—formalist, you could call it. As a guest, Roethke was prone to slipping into the voice of a teacher, intoning at length about poetry and the poets of his generation, but he did not ultimately wear out his welcome. He was a favorite of the family.

One August afternoon in 1963, Roethke mixed mint juleps by the pool while chatting with Virginia and her daughter Eulalie. Virginia stepped into the house for a moment for an errand; perhaps the phone had rung. When she returned, she found the poet floating facedown in the water. Three pretty mint juleps stood on the table.

That is the story told about the famous poet's death in the Bloedels' neighborhood—at least, according to a writer for *The Stranger* who grew up there. As the *New York Times* described the incident, Roethke died "apparently of a heart attack…while wading in a neighbor's swimming pool. He died 25 minutes later."

Grieving, the Bloedels filled in their pool and transformed it into a Zen rock garden. The public can visit it at what is now the Bloedel Reserve, although there is no plaque marking it as the place where the poet died. But in town, at the Blue Moon Tavern where Roethke celebrated his Pulitzer and Bollingen Prizes, a portrait of the poet enjoying a dark stout hangs on the wall. The Seattle City Council named the alley behind the pub "Roethke Mews" in his honor. And in Michigan, Roethke's childhood home in Saginaw is operated as a museum by the Friends of Theodore Roethke Foundation. It hosts tours, writing workshops, poetry readings and open houses for teachers. Beatrice, Roethke's widow, attended the three-day celebration of Roethke's 103rd birthday in 2011. Saginaw Valley State University commemorates the poet in the triennial Theodore Roethke Poetry & Arts Festival, and the University of Michigan named its Hopwood Award for the best extended poetic sequence after Roethke.

The poet's ashes are interred in Saginaw's Oakwood Cemetery, the same place where his parents are buried. Two months after his death, Stanley Kunitz wrote in the *New York Review of Books* that Roethke "meant most to me, in his person and in his art." Roethke did not live to see his final book of poems, *The Far Field*, published in 1964. He did not see it win that year's National Book Award. But he might have been pleased with how his work was understood as an extension of his very life. In reviewing *The Far Field* in the *New York Times*, X.J. Kennedy wrote:

> *When only a summer ago death struck Theodore Roethke, poet and teacher, many must have felt as though some giant redwood tree had disappeared. Probably it is rare for any poet to be so loved personally as was this large, gruff, shy, visionary and clowning man. Now all we have left are his poems. With this last sheaf, they make an abundant legacy.*

Chapter 7
Action Sequence

Elmore Leonard and Donald Goines

Fans are fond of calling Elmore Leonard "the Dickens of Detroit." It highlights the writer's extraordinary ear for day-to-day life, his eclectic ensemble of characters and his pitch-perfect dialogue. But the moniker also recalls a writer who, like Leonard, wrote popular fiction that earned critical literary acclaim. Both Charles Dickens and Elmore Leonard were astonishingly prolific—Leonard churned out more than forty novels over his lifetime, as well as numerous short stories, essays and screenplays. Both Dickens and Leonard reached mass readerships with their brash prose. Both had an intuitive understanding of the sentiment and street-swagger of their particular cities. And both had the skill, talent and taste that elevated their fiction from throwaway pulp to lasting art.

Of course, while Dickens is known for his novels of abundance—he wrote colorful maximalist tomes—Leonard is celebrated for just the opposite: his prose is pared down, stripped clean to the bone. Their different styles suggest the cities from which the two writers came. The London of Dickens's time saw unprecedented growth; between 1815, the year Dickens arrived in the city, and 1870, the year he died, London's population quintupled. A culture of teeming industry and crowded city blocks emerged, which Dickens mirrored with his long, languorous sentences and swarm of characters. The Detroit of Leonard's time experienced the ghostly inverse. In 1950, the year Leonard graduated from high school, the city peaked at 1.8 million people. Urban planning projects scaled the city for a population expected to tip over 2 million residents. Instead, the city steadily contracted over the next half

century as residents moved en masse to the suburbs and beyond, leaving behind neighborhoods pockmarked by empty homes. Leonard himself was part of the exodus.

Leonard was born into a General Motors family. Because of his father's job as a location scout for GM dealerships, they moved around the United States for several years before settling in the Motor City in 1934, when Leonard was not quite ten years old. They first moved into the Abington Apartment Hotel at 700 Seward Avenue; Tommy Bridges, the Detroit Tigers pitcher, was their neighbor. Later, they moved into an attractive unit in the grand Moorish-style apartment building that stood at 70 Highland Street in Highland Park. Leonard attended elementary school at Blessed Sacrament, sang in the church choir and played on city-league football and baseball teams. One fine afternoon when Leonard was in sixth grade, he put up seven cents to take a streetcar to the foot of Woodward Avenue. Then he paid a nickel to take the chugging ferry across the Detroit River to Windsor, Ontario. He never left the boat; he just rode to Canada and back. Once he planted his feet back in Detroit, he stopped in at the Vernors plant and got himself a free ginger ale.

Leonard went on his first date with a girl named Helen Roach; he was in seventh grade, and she was in fifth. He escorted her to the Highland Theatre, a small cinema in Highland Park. When he entered high school, he began at Detroit Catholic Central; the school was still located in the city, on Belmont Street. But when his family moved into an apartment building in Palmer Park on the city's northwest side, Leonard enrolled at the nearby University of Detroit Jesuit High School. He found a rousing intellectual climate that encouraged serious reading and discussion. Teachers plied the questioning Socratic method to guide students in thinking for themselves. Leonard took four years of Latin and two years of Greek. One of his teachers was an early champion of Leonard's aspirations to become a writer. Meanwhile, it was a casual classmate—not even a close friend—who baptized Leonard with his lifelong nickname: "Dutch," after the Washington Senators pitcher Emil "Dutch" Leonard, who threw a mean knuckleball. He later had it tattooed on his arm.

Leonard's family had lived in Detroit for less than two years when, over on St. Aubin Street, Myrtle and Joseph Goines welcomed their first and only baby boy. They named him Donald Joseph. They could not have known

Sacred Heart Church on Eliot Street in Detroit. Donald Goines attended the parish's elementary school. Fall 2014. *Anna Clark.*

it, but the sweet, squirming little newborn was destined for an astonishing literary career—but one that was all too brief.

It is unlikely that Leonard ever met Donald Goines. But their paths in life and literature mirror each other, and not just because they were practically neighbors. Myrtle and Joe were middle-class residents of the North End who ran a dry cleaning business. They were the first in their neighborhood to have a television, and the car in their driveway always looked shiny and new. Sometimes the Goineses needed their three kids to help out at the laundry on evenings and weekends, but they also enjoyed taking the little ones across the river to Canada to go horseback riding or to play in the riverfront parks. Holidays were an occasion for spectacular feasts, with Joe bringing home slaughtered hogs that Myrtle and other women in the neighborhood prepared. Like Leonard, Goines was enrolled in Catholic schools as a child. He started kindergarten on September 2, 1941, at Sacred Heart elementary, which was the designated parochial school for African Americans. Goines, like Leonard, was a small child with a slight frame, but he also played neighborhood baseball. He turned out to be a pretty good pitcher.

Goines grew up to write sixteen novels over four years in the 1970s, a fever-pitch pace that had him writing a few of his books in less than a month. His titles include cult classics like *Dopefiend, Eldorado Red* and *White Man's Justice, Black Man's Grief*—fast-break crime fiction focused on the inner city at a time when urban policy and popular opinion had given it up for dead. While occasionally set in Los Angeles or New York City, Goines typically told Detroit stories, precisely mapping out the city's topography—everything from "Ford's Hospital" to 7 Mile Road. *Daddy Cool* opens in Flint, Michigan, where the title character tracks down a target through a residential street. "The neighborhood had once been attractive, with the large rambling houses built in the early twenties," Goines wrote. "But now, they were crumbling. Most of them needed at least a paint job."

Goines told high-style tales that picked up on the blaxploitation momentum of the early 1970s. His publisher called them "black experience novels." Today, the code word is "urban fiction" or "urban street fiction." In the hands of Goines, they were relentless stories about drugs and violence, but beneath the drama, he kept his characters at the center. His fiction is powered by distinctive voices, in the same way that Harriette Simpson Arnow brought her characters to life with Appalachian dialect. The street slang sings in books like *Eldorado Red*, where Samson hassles his partner in crime for wanting to spend his share of ill-gotten money on a fancy new car:

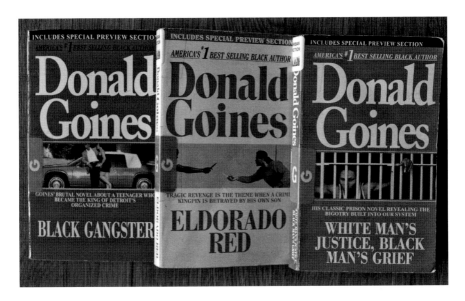

Three well-thumbed Donald Goines novels at the Detroit Public Library. *Anna Clark.*

"Listen, my man," Samson began, "let me try and pull your coat so you can see where I'm comin' from. If you popped up with a Caddie for a ride, your old man's got to be wonderin' where you got the cash, so the next thing he'll do is have his watchdogs check out your friends. That's us. Now the rest of these guys are going to be spendin' their money on clothes and things like that, so when the watchdogs come around, it's goin' ring a bell with them. How come these guys got sharp all at once, plus you with the heavy ride, adds up to us knockin' off a joint. Even a blind man can dig where I'm comin' from, Buddy."

While Goines glorified the graphic details of the gangster world—he portrays it as awash in cash and Cadillacs—he also flirted with a theme of karmic retribution. *Crime Partners* introduces the character Kenyatta, named after the first president of independent Kenya. He acts as a sort of heroic alter ego for Goines. Kenyatta is a rogue who operates a Black Panther–esque organization that stands up to drug pushers and fights to reclaim the streets for the community. This kind of storytelling hit a nerve. Black urban men, an audience long neglected by publishers, embraced Goines's street-style thrillers. To date, they have sold more than ten million copies.

As Detroit novelists writing crime fiction in the '70s, Leonard and Goines both had a taste for clean prose and well-tuned dialogue. Both found

tremendous popularity—albeit among different audiences—and both put the Motor City at the heart of their high-energy novels. But there was just one key difference. The stories Goines wrote were not the products of his imagination and his research. They were his life.

Leonard graduated into the heat of World War II in 1943. He tried to join the marines but was rejected because of poor sight in his left eye. He ended up in the navy, spending three years in the South Pacific with the SeaBees, a construction battalion. Officially, his job was to maintain an airstrip for fighter planes, but when Leonard was asked to sum up his wartime experience in New Guinea and the Admiralty Islands, he said only that he "passed out beer and picked up garbage."

When Leonard returned stateside in 1946, he moved back into the family apartment in Palmer Park. With the help of the GI Bill, he enrolled at what is now the University of Detroit–Mercy, where he rigorously approached his literature and philosophy classes. In 1948, Leonard's father opened a car dealership in Las Cruces, New Mexico—the opportunity to have a dealership of his own was a reward for the longtime GM employee, and Elmore Senior hoped to pass on the business to his son. It was such a cherished company tradition that there was a training school dedicated to working with dealers' sons; Leonard planned on attending it after college. But six months after his father received the dealership, he abruptly died of a cerebral hemorrhage. In an effort to keep the Las Cruces business, Leonard and his brother-in-law tried to work out a payment plan with GM's finance arm. But their claim was rejected—"thank God!" Leonard later said. The company's regional manager, though, happened to be a friend of Leonard's parents.

"I understand you're interested in writing," he said. Leonard was surprised; he had not really written anything yet. His mother must have told the man. The executive thought that advertising might be a good way for Leonard to indulge his writing habit. He connected him to Campbell-Ewald, the advertising agency that held GM as its lead account for nearly a century. Its offices were in GM's world headquarters in Detroit's New Center, the neighborhood adjacent to the North End, where Goines lived.

Leonard moved in with a friend in Lathrup Village while he finished his degree. He graduated with majors in both English and philosophy in 1950, a year after marrying a young woman named Beverly Claire

Cline. He accepted a salaried copywriting job at Campbell-Ewald. He was not much more than an office gofer—delivering messages, buying plane tickets—but he and Beverly nonetheless took a leap and bought their first house. The Lathrup Village home cost them $13,500. They paid $78 a month on the mortgage.

Education did not come so easily for Goines. His older sister Marie remembered him as a poor student with no particular interest in reading or writing. At Sacred Heart, he was held back for third grade. Midway through the 1945–46 school year, his parents put him in Detroit public schools, though he continued to attend Mass with his mother and sisters on Sundays. Joe, his father, was not much for church services, but he did drive the Sacred Heart nuns to their summer retreat each year.

The family moved to Dequindre Road, near Davison Avenue. They opened a new dry cleaning facility near their house, one with an on-site plant. It did quite well. Meanwhile, Goines entered Davison Elementary. There were no more nuns in the classroom, but there were many more immigrant children. In *The Dollmaker*, Simpson Arnow describes Detroit Public Schools as they were in the very same year that Goines enrolled in them: crowded, and housed in a building surrounded by "the strip of trampled snow that made the school yard." Goines was assigned to an "open-air" section of the school—as with some of his cousins, doctors had found an unsettling spot on his lungs—but work in the classroom did not get easier as he grew up. Whether it was because of undiagnosed learning difficulties or a failure to take schoolwork seriously, the only A's he earned in his three years at Cleveland Junior High School where in a class called Household Mechanics. He did no better in English than he did in math. He did like playing baseball for Cleveland, however. He was a strong left-handed pitcher.

At home, Myrtle doted on the boy she called "Donnie." But Joe appeared to favor his daughters over his thin, scrawny son. Whether the perception was fair or not, it created a wound between them that never healed. Myrtle and Joe also drank a touch too much, sometimes slipping out to their dry cleaning business after hours to enjoy a bottle of Canadian whiskey. It raked on Goines that they rarely showed up for his baseball games at Cleveland.

It was not just the schoolwork that was dragging him down. His classmates teased him for his small size—he grew to be about five feet

six inches—and his appearance. Goines had light skin and blue-green eyes. Myrtle had always been told that her Arkansas family descended from Confederate leader Jefferson Davis and an enslaved woman named Frannie. With her light hair, Myrtle could pass as a white woman. Once, while traveling in Evanston, Illinois, and carrying her infant daughter in her arms, a white woman approached to admire the child. Thinking she shared a racial heritage with Myrtle, she was surprised to see a dark-skinned child swaddled in the blankets. "Oh," she said, "I've always wanted one for a pet." Myrtle carefully set the infant down and then proceeded to thrash the woman with her purse.

Kids called Goines "albino" and laughed at his "yellow" skin. When he started hanging around kids on the street who were up to no good, it was a relief. It felt like an escape from the taunting and schoolwork that made him feel he wasn't good enough. He skipped school—he missed nearly seventy days of class at Cleveland—and he followed his new crew into the Black Bottom neighborhood. He learned to card hustle and shoot craps. Small-time gambling made him some cash, and it was a lot more fun than working in the hot rooms of his parents' laundry. While prowling the neighborhood, Goines observed the street-corner hustle. Rather like Theodore Roethke, Goines coped with his diminished self-esteem by harboring gangster fantasies: he wanted to be big, bad, intimidating, untouchable. Perhaps sensing that his son was drifting away, Joe tried to entice him back home. He set up a recreation room above the laundry plant, with a billiards table and record player. Goines and his sisters could invite their friends and cousins over. The room ended up being the place that Goines and his teenage buddies dragged a stolen safe. They broke it open and pocketed the cash inside. When Marie unexpectedly came upon the band of thieves, Goines handed her a twenty-dollar bill.

Joe argued with his son about his future. Where was he headed? Why couldn't he apply himself? Didn't he want to take over the dry cleaning business someday and make a decent living? Goines began ninth grade in 1951 at Pershing High School on the northeast side, but he dropped out before completing it. He soon lied about his age by altering Marie's birth certificate so that he could join the U.S. Air Force. Marie believed that Goines signed up as a way to escape the street mischief that threatened to catch up with him. Others believed it was a last-ditch effort to avoid conflict with his imposing father. Either way, joining the military devastated his mother. Joe kept his feelings to himself.

Goines was only fifteen years old when the air force stationed him abroad during the Korean War. He was more than eleven thousand miles away

from home. During his posts in both Japan and Korea, Goines experimented like the wide-eyed teenager he was, lured by temptation, rebellion and an unbelievable amount of freedom. He visited sex workers—he came home with photos of himself with them—and he got accustomed to heroin. After an honorable discharge from the military when he was seventeen years old, Goines returned to Michigan. His drug habit came with him.

Goines moved into the recreation room above his parents' shop, but he had no interest in learning the dry-cleaning business. Instead, he stayed up late, slept in late, smoked weed and picked up where he left off; gambling and bootlegging eventually escalated to pimping, car thievery and armed robbery. In 1961, Goines was convicted of sticking up a house on East Canfield, along with two accomplices, and he spent the next year in Jackson State Prison. In 1964, he concocted a plan to make whiskey with his pal Curtis Stewart and sell it to after-hours bars. He was arrested and served eighteen months in a federal prison in Terre Haute, Indiana.

Joining the corporate world at Campbell-Ewald did not mean that Leonard put off his fiction. Neither did his growing family: Beverly gave birth to a daughter in 1950, the first of their five children. Each morning, Leonard set the alarm clock just before five in the morning. It took him a few months before he could wake easily, but he did it. Then he crept down to a cinderblock basement with concrete floors, careful not to wake his sleeping family, and he sat down at his little writing desk. He wrote longhand in yellow notebook tablets until 7:00 a.m. Each day, he revised what he wrote the day before, and when a draft was finally coming together, he typed the story on his IBM Wheelwriter. To keep up his motivation, he did not permit himself a sip of morning coffee before he started to write. After he was through, he headed to church nearly every morning to receive communion, and then he went to work at his "real" job. The chain-smoking adman eventually managed advertising for a Chevrolet truck account. Leonard snuck time at work to write fiction, inking stories on a legal pad in a desk drawer that he slammed shut if anyone strolled by.

Leonard's discipline paid off: he made inroads in the Western pulp market of the 1950s, publishing dozens of short stories and several novels over the decade. "Trail of the Apaches" in 1951 was his first publication, a story that appeared in *Argosy*. It was about fifteen thousand words long, and it had

Elmore "Dutch" Leonard at the corner of Woodward and Trowbridge, one block from where he played games like Hot Cooloo with his friends. *Courtesy of the* Detroit News *archives.*

almost no dialogue. Not only did it earn him a $1,000 paycheck—equal to one-third of his starting annual salary at Campbell-Ewald—but it also caught the interest of a New York literary agent who offered to represent him. Two years later, he was out with his first novel, an adventure story called *The Bounty Hunters.* In his first decade as an author, Leonard wrote thirty western stories and five western novels, including the celebrated book *Hombre.*

Leonard is the rare writer who scarcely had an apprenticeship or years spent laboring on his craft in near anonymity before finding widespread publication. This was not an accident. He had a reliable middle-class income, even if he was not enthusiastic about his job, which gave him the opportunity to work from a place of comfort. He chose to write westerns not only because he liked the films but also because there was a seemingly limitless number of pulp magazines publishing cowboy stories. "I don't think you could help but sell," he said. And so, his imaginative life lived many years in the bright, dusty Arizona desert, a place of wide skies, stubborn ranchers and slow-talking sheriff deputies.

In 1961, Campbell-Ewald's profit-sharing plan made it possible for Leonard to quit his job and become a full-time writer. But the plan only halfway worked. Leonard and his family had moved to Birmingham in the

1950s. It was a pretty enclave halfway between Detroit and Pontiac that was growing into an increasingly fashionable community. The new expenses, and the heavy price tag that comes with raising five kids, forced him to take on freelance gigs. He did some ad work on contract and wrote educational scripts for little films made by Encyclopedia Britannica. He got another chance at full-time writing in 1966, when his novel *Hombre* sold to Twentieth Century Fox for $10,000. That check was the financial cushion Leonard needed to focus on his fiction.

He got in the routine of writing from 9:30 a.m. until 6:00 p.m. five days a week and occasional weekends. He kept that pace for nearly the rest of his life. By the mid-1970s, he had shifted from his home writing desk to a three-office suite above Whalings Menswear on Pierce Street in Birmingham. Between fiction and scriptwriting, he was earning six figures a year.

There was, of course, one good thing about Goines being locked up: it was the only time he was free of drugs. Perhaps feeling more clear-headed than usual at the prison in Terre Haute, Goines thought he might try his hand at writing fiction. He wrote his first novels while incarcerated in the mid-1960s—westerns. Goines had always loved western flicks; he was inspired by their popularity and high-pitch action, just as Leonard was. Cowboy stories were a favorite among inmates, passed from hand to hand. Goines also wrote nonfiction. His article on Dr. Martin Luther King Jr. was published in the prison newspaper.

But once Goines got back to Detroit, he picked back up with his habit, cooking heroin with a cigarette lighter while at the same time warning his little sister Joan to not follow the path he had taken. "He told me that if I ever did he would kill me," Joan said. He tried hard to drop it. He hated that the drug drove him to commit crimes, just so he could rustle up the money to buy a dose. As he got older, the cycle became more and more of a burden. At his family's home, Goines locked himself in a bedroom and made Myrtle and Joan promise not to open the door, no matter what. When withdrawal symptoms kicked in, his mother and sister listened nervously to him slam, groan and pound from the bedroom. The heroin leaving his body left him sick, desperate and achingly loud. He begged them to open the door. He screamed at them, and he cursed, but out of love, they did not turn the lock. But then Goines escaped through a bedroom window. Or he pummeled his

small, strong body against the door and broke it down. And it was right back to the drugs.

"He didn't control the habit," Joan explained to Eddie B. Allen Jr., author of the indispensible biography *Low Road: The Life and Legacy of Donald Goines.* "The habit controlled him."

Leonard's stylish novels and stories were becoming Hollywood fodder, with five of them—*The Tall T, 3:10 to Yuma, Hombre, Valdez Is Coming* and *Joe Kidd*—adapted for the screen before Leonard was fifty years old. Throughout the 1970s, he moved back and forth between writing screenplays and novels, so that the style of one inevitably inflected the other: dialogue rather than exposition began to move his fictional stories forward. But popular taste for westerns was fading. So Leonard stretched his writing into a new commercially popular genre: crime. His turning point was "The Big Bounce," a 1969 story about a frustrated ballplayer with a moneymaking scheme. The novel *Glitz* (1985), about an ex-con seeking revenge on a Miami Beach cop, was his breakout book. As successful as he had been as a writer before, it wasn't until *Glitz* was published that Leonard achieved top-tier recognition. The bestselling novel put him on the cover of *Newsweek* for a feature titled "The Big Thrill: Mystery Writers Make a Killing." It awakened enough interest in Leonard that his publisher rereleased earlier books that had fallen out of print.

What made Leonard's crime writing interesting is that he did not churn out "whodunit" novels. He did not publish over-boiled rewrites of Dashiell Hammett and Raymond Chandler. What Leonard did was reinvent the modern thriller. He shoved plot into the background; he brought character to the foreground. Unlike his noir-style predecessors, Leonard began writing his stories without knowing how they would end. By getting out of his own way, he let a vivid cast shine through—hustlers, con men, money-grubbers, peacocking investigators and world-weary average joes. He had an unusual capacity to render villains because he was able to understand the story from their perspective—they did not see what they were doing as evil. In portraying that, Leonard provoked assumptions about common moral codes: Who ultimately stands on the right side of the law? What laws matter most? What is law for, anyway?

ACTION SEQUENCE

In 1969, Goines was back at Jackson State Prison, serving eighteen months for attempted larceny. As the days dragged on, Goines was looking for something to read. A fellow inmate suggested that he take a look at a book by Robert Beck, otherwise known as Iceberg Slim, which detailed the bleak and brutal life of working as a pimp. Goines was amazed to see a world that he recognized described on the pages. There it was, in black-and-white: the drugs, the sex work, the violence—even the bit of humor and kindness that sometimes showed through. Goines set aside his cowboy stories and began to write crime fiction, drawing from the street life that he knew. Ever the supportive mother, Myrtle hauled a typewriter out to Jackson for him to use.

While still behind bars, Goines wrote *Whoreson*, a novel about a man born to a sex worker who grows up to become a pimp. At one point, he cons a woman out of money by staging a fake wedding and pretending to marry her. Goines had one of his fellow inmates take a look at the manuscript, and with his friend's encouragement, he mailed it to Holloway House, the same Los Angeles company that published Beck.

Goines was back in Detroit when a contract came in the mail. Holloway House signed him in 1970 and paid him an advance for more of his work. It first published *Dopefiend: The Story of a Black Junkie* (1971), about the twisted power dynamics between a drug dealer and a user. It gives a commanding picture of how Goines understood his own wretched addiction. *Whoreson* (1972), which turned out to be the only novel that Goines wrote in the first person, was released a year later.

Goines was on a roll, beginning the years of his extraordinary creative output. The material of his imaginative world came straight from life. "Donnie was using people. Real people, man," said Ralph Watts, who knew him personally, to Goines's biographer. High points of his literary production include *Black Gangster* (1972), about a revolutionary group that is a front for crime, and *White Man's Justice, Black Man's Grief* (1974), about inequalities in the criminal justice system. The latter is set in Michigan's Wayne County jail and Jackson State Prison. And then there are the four Kenyatta novels. *Crime Partners*, the first in the Kenyatta series, is also the first book that Goines published under the pseudonym "Al C. Clark." Holloway asked him to use another name because his books were coming out too quickly: it risked market saturation. The publisher did not want to lose sales by having too many Goines titles competing against one another on the display racks.

His books were so explicit that many libraries, including the one in Detroit, banned them. But the paperbacks were passed around nonetheless, friend to friend. They dominated the racks in convenience stores and newsstands. His popularity skyrocketed. While readers could not expect an arc of redemption in Goines's fiction, they could delight in the author's genius for characterization and voice. They could look forward to how a Goines novel was not didactic but still powerfully suggested how exploitation between individuals—pimp, sex worker and john; drug dealer and addict—paralleled broader systematic exploitations in politics and culture. And Goines made the point in clear, vivid, excruciating detail, drawing out a story that resonated as real.

Literary success, though, could not cure Goines of his addiction. He spent obscene amounts of money buying heroin, up to $100 a day. That works out to more than $500 a day in today's dollars. Goines worried that he could not write without being high. It was a terrible cycle. He needed money to fuel his habit, and because he felt pressure to make that money legally, he churned out books at a feverish pace. He depended on his books to get more drugs, but he depended on his drugs to write his books.

Leonard almost never wrote anything longer than three hundred pages. The books that tipped that margin were typically later works that are weaker than his trimmer novels. The taut prose that makes up the bulk of his work, however, is scrubbed of authorial fingerprints. Leonard's genius for straight-ahead sentences and his restraint against overstuffed plots earned him comparisons to Ernest Hemingway. Leonard was a longtime fan of Hemingway—if he needed to get the creative juices flowing, he picked up his beloved collection of Hemingway's short stories or the novel *For Whom the Bell Tolls* and started reading at a random place. Leonard learned to write dialogue from him and how to narrate a character's internal thinking. But he also thought Hemingway tended to be self-serious and humorless; few things bothered him more than literary pretension. Throughout his life, it was writers who paired simplicity with clear-eyed storytelling that captured his imagination. Besides Hemingway, he was a fan of John Steinbeck, James M. Cain, Richard Bissell, Jayne Anne Phillips, Raymond Carver, George Higgens, Bobbie Ann Mason and Jim Harrison. Later in life, when Leonard gave frequent speeches to literary audiences, he carried a little list of his

favorite authors in his pocket so that he would not forget to name any one of them.

Leonard's first crime novel set in Detroit is *52 Pick Up* (1974). It is the tale of Harry Mitchell, an ace pilot during World War II turned self-made businessman. At the helm of a successful manufacturing firm near Mount Clemons, Harry has come to be a pillar of the community. He jogs every morning through his Bloomfield Hills neighborhood. He serves on the Urban Renewal Committee, the Bloomfield Village Council, the Deprived Children's Foundation and a number of other civic posts. He has enjoyed a happy marriage for more than two decades, and he is the father to two bright children. You would call him a success by any measure. But when Harry starts an affair with a young model, it is not long before masked men confront him. They demand that he pay them $105,000 a year or they will release a film of his infidelity. "It's a shame, ain't it?" one of the extortionists proclaims. "Everybody trying to mess up everybody." But Harry has no intention of quaking in the face of blackmail. The push-pull of escape and revenge forms the crux of this high-energy tale.

The novel introduces Bobby Shy, a crook wearing a light-gray business suit and sunglasses when he kidnaps a Gray Line sightseeing bus on Woodward Avenue. He robs the riders and then gives them a brief rogue's tour of Detroit. "Those places you boarded up?" he says over the microphone. "Historic remains of the riot we had a few years ago. Got me a fine hi-fi set and a 'lectric toothbrush...color TV for my mama." When he and his accomplice exit the bus near the Chrysler Freeway, Bobby looks up on the tense faces of the passengers. "Detroit's a great big wonderful town, ain't it, gang?" he says. "Enjoy yourselves. And thank you."

The novel was adapted in a film in 1986, directed by John Frankenheimer, but the filmmaker changed *52 Pick Up*'s setting to Los Angeles. This was a familiar pattern. Despite the frequent filming of Leonard's cinematic novels, and despite his use of Detroit as a setting, there have been almost no adaptations of Leonard's Detroit stories that are actually filmed in Detroit. *Touch*, a 1997 adaptation by director Paul Schrader, also shifts the original novel's downtown Detroit setting to Los Angeles. *Life of Crime* (2013) is based on the 1978 novel *Switch*; it was Leonard's first novel to feature a female protagonist. The script sets the story in Detroit in the 1970s, but it was filmed in Connecticut, reportedly because one of the stars, Jennifer Aniston, felt uneasy about a Detroit shoot.

While Leonard's writerly star was on the rise in the 1970s, his personal life crashed. He realized that he was not simply a heavy social drinker who

enjoyed a good party at his suburban country club; he was a full-blown alcoholic. "I thought that if I wasn't drinking I'd be bored," he said. He came back from a trip to Hollywood throwing up blood, and a doctor diagnosed him with acute gastritis. "That's something you see with skid-row bums," the doctor said, raising his eyebrows at the heavy drinking

Leonard and his wife separated after he had an affair. He moved into an apartment in 1974 and eventually joined Alcoholics Anonymous, a shift that coincided with lapsing in his Catholicism. "I don't go to receive the sacrament anymore," he said. "But it's important to me to go through this little drill about what my purpose is before I get out of bed every morning." On January 21, 1977, at 9:30 a.m., Leonard had his last drink. (His characters didn't give up alcohol, though: he continued to write lovingly detailed descriptions of their bourbon, depicting the precise ritual of drink.) He and Beverly divorced in 1977. Two years later, Leonard married Joan Leanne Lancaster, a Birmingham woman from the country club.

At the same time, Leonard's career as a Hollywood writer was picking up. Like Jim Harrison, who was doing similar screenwriting work at the same time, Leonard never seriously considered moving from Michigan to Los Angeles, even though that seemed to be a requirement for the profession at the time. Like Harrison, a great deal of what Leonard wrote never made it to the screen, but it did bring in paychecks, and that was all that mattered. "The screenplays I did were just a matter of trying to make money; it was work, that's all," Leonard said. His real craft was fiction.

Eldorado Red came out in 1974, the same year that Detroit inaugurated its first African American mayor and the Detroit Lions played their final season at Tiger Stadium before moving out to Pontiac. Goines's novel is about a formidable numbers runner in Detroit who enlists his son Buddy to help him collect cash. Each day, he drives through neighborhoods, stopping by the homes of regular customers. But Buddy is restless and young. He is becoming disenchanted with his situation, and he is hearing dishonorable stories about his father. He partners with three of his friends to rob several of the collection houses, setting the stage for a heartbreaking showdown between father and son.

Goines dedicated *Eldorado Red* to his sisters, Marie and Joan, "because they believed in my writing ability when I had just about given up hope of ever

being published." Later that year, when Goines was thirty-six years old, he moved to Los Angeles with his common-law wife, Shirley Sailor, an attractive woman whom his sisters liked. Goines had dedicated a book to Shirley, too: *White Man's Justice, Black Man's Grief* (1973). "Her love and infinite patience helped me to keep the faith and to make my editorial deadline."

They picked Los Angeles because Holloway House was based in the city. But Goines did not like California. He was broke, and he complained about being hassled by the police. His drug habit was getting no better, even though Holloway executives offered him all kinds of support. When the publisher staged an intervention to help Goines kick his addiction, he insisted that he could manage his problem.

The couple returned to Michigan. Goines and Sailor, along with their children, moved into a multifamily home at 232 Cortland Avenue in Highland Park. (Goines had seven kids in all but never married.) He continued his fast pace of writing fiction.

In the early evening of Tuesday, October 4, 1974, the Highland Park police department received an anonymous phone call that told officers to hurry over to the house on Cortland. They found Goines and Sailor dead of multiple gunshot wounds to the head and chest. Lore has it that Goines

Empty lot in Highland Park where 232 Cortland Avenue stood. It was the final home of Donald Goines. *Anna Clark*.

was killed while sitting at his typewriter in the living room. Sailor was found in the kitchen. Two of their small children who were at home at the time were unharmed. The murders remain unsolved, though speculation suggests that possible motivations were drug debts and too-close-to-true characters in Goines's novels.

Organ music filled an east-side church for Goines's funeral. Myrtle tucked a paperback copy of *Daddy Cool* under the arms of her son as he lay inside his coffin. While his life had ended, his writing had not. Two more of his books, *Kenyatta's Last Hit* and *Inner City Hoodlum*, were published posthumously in 1975, though Holloway had to hire another writer to complete Goines's unfinished manuscript for the latter.

Goines was buried in Detroit Memorial Park Cemetery in Warren, Michigan. There is no headstone to mark him, just a tiny flat grave marker in an overgrown lawn. At some point, the house on Cortland was demolished. It is now an empty lot, three blocks from the MacGregor Library.

But if traces of the life Goines lived are difficult to find these days, his literary influence is everywhere. His books sell a quarter-million copies a year and have never been out of print. "America's #1 Bestselling Black Author," boasts the promotional text on the newest editions.

Leonard got in the habit of lurking around Greektown in the late 1970s, mostly at 1300 Beaubien, the historic Detroit Police headquarters. It is a grand nine-story building designed by Albert Kahn that opened in 1923. Today, it is vacant; the police moved its homicide department into brand-new headquarters in 2013.

For Leonard, the building was a place to catch on to how officers spoke and worked. *Detroit News* reporter Norman Sinclair introduced Leonard to his sources in the homicide department, and Leonard trailed them for weeks. He wrote a long cover story about what he saw for the *Detroit News Sunday Magazine* headlined "Squad 7: Impressions of Murder." He used the jargon he learned in his prose. On the page, as well as in real life, "1300" was the nickname for the police headquarters.

Landmarks of Detroit culture, high and low, began to show up in Leonard's fiction. That includes *City Primeval: High Noon in Detroit*. Leonard's 1980 novel is about a psychopath named Clement Mansell, known as the "Oklahoma Wildman," who murders a corrupt judge before moving into an apartment

Number 1300 Beaubien, the former headquarters of the Detroit Police Department. Elmore Leonard had a habit of hanging around with the homicide detectives. Fall 2014. *Anna Clark.*

Looking up in the GM Wintergarten in Renaissance Center in downtown Detroit. *Kevin Robishaw*.

on the twenty-fifth floor of the 1300 Lafayette apartment building. From the high-rise, he has a view of Detroit's then-new Renaissance Center on the riverfront. The complex of mirrored towers—"massive dark-glass tubes"—appears as a laughable luxury. Sunlight reflects with absurd flash. The "Buck Rogers monument over downtown," it's called. The RenCen is "all rough cement, escalators, expensive shops and ficus trees." A woman who works as a cocktail waitress at a restaurant in the RenCen quits after six months because "she could never find her way out of the complex with all its different walks and levels and elevators you weren't supposed to use." Locals enjoy the fact that this restaurant is called Nemo's, which is the name of a real-life restaurant in Corktown that is a popular pre-game spot for Detroit Tigers fans.

Elsewhere, Leonard's fiction spotlights the Athens Lounge, which was the old cop bar on Monroe Street, and Bouzouki Lounge, a nearby strip club. The J.L. Hudson Company, the downtown department store, makes frequent cameos. In *Swag* (1976), Stick and Frank attempt a robbery at the posh twenty-five-story shop. *Up in Honey's Room* (2007), set in the twilight of World War II, introduces Honey Deal, who works as a buyer in the Better Dresses department.

> [Honey was] *moving up in her world from a flat in Highland Park to a one-bedroom apartment on Covington Drive, a block from Palmer Park where she'd learned to ice skate in the winter and play tennis in the summer. At night she would hear the streetcars on Woodward Avenue turn around at the fairgrounds and head back six miles to downtown and the Detroit River.*

One cannot help but compare Honey Deal with Gertie Nevels from Simpson Arnow's *The Dollmaker*. Both are memorable female characters in the same city at the same time, working to make a life for themselves.

Leonard's work reached a new generation of fans through latter-day film adaptations, including *Jackie Brown*, directed by Quentin Tarantino and based on the novel *Rum Punch*, which gives a stylistic nod to blaxploitation films. *Out of Sight*, directed by Steven Soderbergh, reworks Leonard's novel of the same name about a bank robber who targets an unscrupulous businessman in Detroit's northern suburbs. Some of the films were successful enough to drive the course of Leonard's fiction. On the night of the 1995 premiere of *Get Shorty*, MGM studio executives asked Leonard if he had a sequel in him. "I said, 'Sure why not?'" After a few false starts, he wrote the novel *Be Cool*, taking the mobster character of Chili Palmer and putting him in the

music business. "It's so obviously a sequel, perhaps shamelessly aimed at the movies," Leonard said. "That's this book—it's about coming up with the idea for a movie."

A fair share of the films are famously terrible. Leonard loathed the 1985 adaptation *Stick*, directed by Burt Reynolds. Too theatrical, he called it. He tried hard to hammer out the melodrama in his books, and the film just piled it back in. Even before the movie came out, Leonard snagged a movie poster, which pictured a moody Reynolds with a cigarette dangling from his mouth as co-star Candace Bergen gazes upon him. "The only thing he couldn't do was stick to the rules," reads the tagline. Leonard pasted the poster in his den, but he covered up the word "rules" and replaced it with the word "script."

Hip-hop over the last twenty years has fueled the modern-day appreciation for the fiction of Goines. *Crime Partners* and *Never Die Alone* (1974) were adapted into films; rapper DMX produced and starred in the latter, alongside actor David Arquette. In the 1996 song "Tradin' War Stories," Tupac Shakur wrote, "Machiavelli was my tutor / Donald Goines, my father figure." Nas named his song "Black Girl Lost" after the Goines novel of the same name. For his recording for the *Men in Black* movie, called "Escobar '97," Nas rapped, "Eldorado Red, sipping Dom out the bottle / My life is like a Donald Goines novel." And then there is Ludacris in "Eyebrows Down": "So I picked up a couple books from Donald Goines / About the business of this shit and how to flip a few coins."

At the same time, *Dopefiend* has been taught in a Rutgers University course on crime and punishment, alongside the work of Frederick Douglass and Upton Sinclair. *Black Girl Lost* is on the syllabus of a literature course at the University of Houston, right between novels by Maya Angelou and Sherman Alexie. An English class at the University of Mississippi teaches Goines in the context of James Baldwin, Ernest Gaines and Angela Y. Davis. His work has been translated into French and found large audiences. He is also one of the most-requested authors in American prisons. "Donald Goines is bar none the most popular writer among inmates," wrote a prison librarian in Maryland in a 2006 essay. "Over and over again I'm being asked if we have his novels…[The] fact that convicts keep on reading his books tells me that it's genuine, that the stories Goines told and the characters he created resonate with people who know all about the milieu he portrayed."

Mary Driscoll, a librarian in the Dane County Jail in Wisconsin, echoed the point in a *New York Times* interview. "Donald Goines is across the board our most requested writer," she said. "Because he lived the life, his books really speak to that population."

Goines was eleven years younger than Leonard. He lived fifty fewer years than him, and he wrote far fewer books. Still, he was able to achieve a similar balance between so-called high and low culture. His literary work resonates both on the street and in the ivory tower.

Detroit was not Leonard's only story; he plotted novels in Miami, New Orleans, rural Kentucky, south Florida and, certainly, out west. But he managed to capture the city at an epochal moment of its history; he shaped it in the imaginations of millions of people. And it is the city he chose for himself, even as screenwriting lured him to California.

"Woodward is Elmore's 'Heart of Darkness.' It's 'The River Runs Through It,'" George Sutter, Leonard's longtime friend and researcher, told the *Detroit News*. "The street runs through all his stories, his consciousness from child to now."

Leonard's exploration of the city was not limited to his research. He saw jazz shows at the Max Fisher Music Center on Woodward Avenue, and he got high watching the Grateful Dead perform at the Majestic Theatre. Each year, he taught a guest class at his old high school, University of Detroit Jesuit. He was a frequent customer at the Paradiso Café on Woodward. On East Jefferson, near the Belle Isle bridge, he took his kids to lunch at Little Harry's, a restaurant in a splendid Federal-style house built in 1855 with red brick, green shutters and a tree-filled lawn. At Little Harry's, you could order "Diamond's Blue Plate Special"—chicken pot pie, French fries, slaw and a beverage—for $1.75.

At heart, though, Leonard was an Oakland County man. When a *New York Times* writer profiled him in 1984, ahead of the publication of *Glitz*, Leonard took him to Birmingham's Midtown Café, which his son Chris managed. (Leonard ordered broiled shark steak and ginger ale.) He made his final home in Bloomfield Township, at 2192 Yarmouth. Cigarette smoke stained the living room walls around his writing desk. (While favoring True cigarettes for much of his life, he got hooked on Virginia Slims 100s after having a character in the Detroit-based novel *Mister Paradise* smoke them.)

This house had sliding glass doors that opened onto a swimming pool and tennis court. Leonard stepped outside every day to feed chubby squirrels with cake, leftover dinner, whatever he had. A framed poster for *Glitz* hung in the foyer, and in the closet, he had a rack of leather shoes.

After his second wife, Joan, died of lung cancer in 1993, Leonard married a woman named Christine Kent. "I felt I had to get married again. Quickly. I like being married." They met when Leonard hired the French-speaking master gardener to do landscaping. When they divorced in 2012, after nearly twenty years together, Leonard was hit with his first extended period of writer's block. He got in the habit of watching daytime television with his much younger girlfriend, and he was not eating as much as he should. He also began drinking again, wine or beer in a stem goblet, because he missed it and he figured he was old enough. His son, the writer Peter Leonard, often came by at dinnertime to make sure he had a proper meal.

That same year, the National Book Foundation awarded Leonard its medal for Distinguished Contribution to American Letters. It was hardly his first literary honor, but it put him in extraordinary company. Previous winners included Gwendolyn Brooks, Arthur Miller and Philip Roth.

"Once I became known," he said in his acceptance speech, "I thought reviewers were going a bit overboard saying the subtext of my work is the systematic exposure of artistic pretension, or that my writing was an indictment of civilization and its byproducts. But the review I think of as the most stimulating, if not a realistic appraisal of my work, comes from *New Musical Express* in London, who called me 'the poet laureate of wild assholes with revolvers.'"

As the laughter died down, Leonard added, "You hope in vain to see a quote like that on the back cover of your next book."

That unpretentious sentiment is why Leonard's favorite fan mail came from people in prison. One letter sounded as if it could have been written by a character in a Goines novel:

> *How I ended up here is a long unbelievable tale involving dysfunctional women, heroin and pure foolishness. Your books are the first ones I've liked and can share with my beloved semi-literate fellow criminals and maniacs.*

The letter went on to say that the man was so impressed with Leonard's dialogue, he felt sure that he must have been locked up too at some point. He had not been, but he did visit prisons when he had the chance. After spending a day with a writing workshop at a Tennessee prison in 1991, Leonard sent

a thank-you note to the group's volunteer leader. "You're doing a great job, giving of your time and talent to help those guys out," Leonard wrote. "I can't imagine writing under those conditions."

———

Eight months after the National Book Foundation ceremony, Leonard suffered a stroke. He was eighty-seven years old. On August 20, 2013, when he died of complications, he was at his home with loved ones at his side.

Leonard left his literary archives to the University of South Carolina, a vast collection that includes manuscripts, typewriters and even a pair of his favorite sneakers. The choice surprised many who had hoped he would choose a Michigan university to safeguard his legacy. Deals with the Library of Michigan and the University of Michigan came close to being sealed, but South Carolina won out in part because it has an extensive collection of archives from crime writers like George V. Higgins and James Ellroy, as well as Ernest Hemingway. When Leonard visited the campus to accept yet another award in May 2013, just months before his death, the collection impressed him. *The Friends of Eddie Coyle*, Higgins's 1970 novel, changed how Leonard approached writing, and Hemingway, of course, was one of his earliest and greatest influences. Touching their papers and first-edition books moved him. On the plane ride home, Leonard set down the book he was reading, leaned over to his son Peter and said, "That was something, at the university. I was impressed. That's where I want my papers to go."

No further words needed.

Chapter 8
What Philip Levine's Work Is

Philip Levine's father came to the United States from Russia, traveling across the ocean all by himself at age fifteen. He grew up in New York City with two older sisters and their families. His path to Detroit was an extraordinary one: he enlisted in the English army, was stationed in Palestine and conjured a new identity (including a new passport) in Cairo.

These are fantastical stories for a child to hear—stories that merge the ordinary with the extraordinary. He was also told that he had Spanish ancestry, which was not true, but it catalyzed Levine's lifelong fascination with Spanish politics, culture and literature.

What is true is that Levine was born in Detroit in 1928, one of a pair of twins born to parents who had grown up in a village in western Russia. An older son was also part of the family. His father was a handsome multilingual man who sold used auto parts. He was only thirty-five years old when he died. Levine was five. His mother, Esther, worked full time at her father's auto parts company and then as a secretary before running her own clothing and gift shops, all while raising three sons by herself. She did it in a community where public discourse was poisoned by the hateful anti-Semitic radio commentary by Father Charles Coughlin, a popular priest at the National Shrine of the Little Flower in nearby Royal Oak. Up to thirty million radio listeners tuned into Father Coughlin's weekly radio addresses, where he championed the political policies of Adolf Hitler in Germany and suggested that Jewish bankers were to blame for the Russian revolution. Meanwhile, Henry Ford, whose successful

automobile company seemed to dominate every part of private and public life, voiced his paranoia about Jewish people. Ford bought the *Dearborn Independent*, his hometown newspaper, in 1918, and he used it as a place to publish a series on the so-called Jewish conspiracy. "Jewish Power and America's Money Famine," read one headline. The articles ran in more than ninety straight issues and were collected in a four-volume book called *The International Jew*.

Levine's family, who lived around 7 Mile Road and Livernois Avenue, were not especially religious—they did not keep kosher or go to shul. Levine's Polish grandmother actually became a Christian Scientist. But the anti-Semitic cultural environment of the time strengthened the family's sense of identity. The King James version of the Old Testament was Levine's first encounter with poetry. Religious cadences entranced him. Around the same time, young men from his neighborhood headed to Spain in the 1930s to fight in the Spanish Civil War. To a child, this seemed like the stuff of myth: a hero's journey into the heart of revolution. Levine's imagination caught fire.

Levine went to junior high at Durfee, a west-side school built in 1927 that still sports the artistic flourishes that made the building a showpiece, including a copper bell tower. Durfee's students came largely from working-class and immigrant families. Levine remembered it in his poem "M. Degas Teaches Art & Science at Durfee Intermediate School," where he describes it as the place where he experienced the shift from book-learning to artistic discovery. He dates the poem "Detroit, 1942" and published it in the collection *What Work Is* (1991):

> [...] *It was early April,*
> *the snow had all but melted on*
> *the playgrounds, the elms and maples*
> *bordering the cracked walks shivered*
> *in the new winds...*

Levine was fourteen in 1942. He was already making up poems, though he didn't think of them as poems; he'd climb trees and say little words and phrases aloud, not to anyone in particular. Around the same time, he began working in a soap factory. In his poem "Growth," also included in *What Work Is*, Levine wrote about his experience as a teenager, wheeling little cars of damp chips into the factory ovens and speaking to no one but his supervisor.

Central High School on Tuxedo Street in Detroit. It is the oldest high school in the city and the alma mater of Philip Levine. November 2014. *Anna Clark.*

> [...] *My job*
> *was always the racks and the ovens—*
> *two low ceilinged metal rooms*
> *the color of slick skin. When I*
> *slid open the heavy doors my eyes*
> *started open, the pores*
> *of my skull shriveled, and sweat*
> *smelling of scared animal burst from*
> *me everywhere...*

Levine clocked hours on the line throughout high school—he studied at Central High on Tuxedo Street, right behind Durfee. He also fell in love with horse racing, a hobby that his mother hated. She was much relieved when Levine graduated in 1946, at age eighteen, and instead of loitering for long at the racetrack, he headed downtown to study at what is now Wayne State University. (He remained an enthusiast of horse racing, however, as well as just about every other sport, especially tennis. "He was also crazy about baseball and basketball," his future wife Franny told me. "He just liked watching games.")

It was at Wayne State that Levine began to write poetry, encouraged by his art-loving mother. "That a son of hers would devote himself to this art thrilled her," Levine said. He discovered the English poet Wilfred Owen, who wrote scorching verses about World War I. With the smoke of the Second World War scarcely settled, Owen's poetry struck a chord with Levine. So did W.H. Auden, who impressed Levine with his ability to write poems about difficult subjects in a way that surprised readers, putting them off balance just enough to create space for insight to come through.

College classes also put modern poetry in front of Levine for the first time. He had never before read poems about urban life. Before, it had all been bucolic lyrics about the countryside that he had pretended to be interested in, and now there was T.S. Eliot's "Preludes," which is carved out of iconic, striking images of the city. "I said, 'Wow, I don't have to fake this nature-love, I can write about what I want.'" Levine explained in an interview with *Tablet*. "My early poems ignored the place I lived in—maybe it was an effort to remove myself, I don't know. That was the first big change."

The second big change was reading Welsh poet Dylan Thomas, who captured the imaginations of young writers of the time with his fast living and his musical, muscular poetry. Levine was hypnotized when Thomas came to the United States on performance tours, awed at how he was able conjure drama in his poetry. "I was very young at the time," Levine said in the *Atlantic*, "and I realized that in order to write like that there was a lot I was going to have to learn to be able to control the line so beautifully and to get that resonance that he had in his writing."

But it is not as if there are many jobs to support that kind of tough poetic work. After he earned his bachelor's degree in 1950, it was right back to the auto plants for Levine. He slogged through the hours in a number of factories. He worked with hot metal at Chevrolet Gear & Axle, built transmissions for Cadillac and punched the time clock at Breslin's First-Rate Plumbing and Plating. This was soul-crushing work for him; "stupid jobs," he called them. "I found the places hateful," he said, "and the work was exhausting."

Levine married Patty Katerman in 1951, but their relationship did not give him much of a respite. They divorced two years later. And then, in 1953, Levine skipped town, leaving the city for good. He married Frances Artley Umland, called Franny, who designed costumes for theatrical productions. He followed her to Boone, North Carolina, where she had a job at an outdoor production. After a summer in the mountains, they moved to Tallahassee, Florida, where Franny got a job in the drama department of the local university. Their first son

attended nursery school, leaving Levine time to hammer out a thesis on John Keats's "Ode to Indolence" for his master's degree in English at Wayne State. In time, the couple found their way to Iowa City, where Levine taught English to freshmen and to engineering majors at the University of Iowa. He also started attending classes at the college's legendary writers' workshop, though he never enrolled and certainly never paid tuition. By simply showing up, Levine had the chance to work with some of the twentieth century's greatest poets, including Robert Lowell and John Berryman. Levine found Berryman—whom he had first met at Wayne State in Detroit—to have excruciatingly high standards and to work on his own writing with passionate sincerity. So Berryman's encouragement meant the world to Levine. "For one thing, he liked what I did, he liked the idea of the guy writing about Detroit," Levine said. "I never had a really terrific poet read my work and really admire it." Berryman also expected his students to be reading far more than they were. They had gotten preoccupied with modern poets, but their instructor nudged them further back to Elizabethan poetry and other older works. Berryman thought Levine in particular should be reading Thomas Hardy and William Butler Yeats.

Levine ultimately earned a master of fine arts degree in 1957. A poetry fellowship at Stanford University lured him to California, and by 1958, Levine had joined the English faculty at California State University in Fresno. The Central Valley city had a population of about 130,000, less than a quarter of what it is today. Levine gave his first poetry readings in San Francisco, alongside poet Gary Snyder, and a full five years after his arrival, at age thirty-eight, Levine finally published his first collection of poems. He titled it *On the Edge.*

"Even in my imagination I didn't want to spend time where I was working," he said. "I didn't want to talk shop. So no, even after I left—because I left Detroit at age twenty-six—I was unable to write anything worth keeping about Detroit for years. I wrote things and I threw them away."

He and his wife bought a small bungalow in Fresno that dated back to 1919, which is about as old as houses get in California. Orange, persimmon and kumquat trees stood in the yard, and Franny tended to a sizeable vegetable garden. Levine gazed upon it from his small study, which he filled with bookshelves and photographs. A mobile hung from the ceiling, made by a friend; thistles, thorns and dried weeds swung from wire, turning in the breeze. "I realized that everything else in my life was secondary [to poetry]," Levine said. "Until I started having kids. And then I realized these things were equal. My love for my wife and my children, and my love of poetry. I somehow had to work out a way to be a good husband, and a good father and yet save enough time and energy to be a good poet."

Portrait of Philip Levine. *Geoffrey Berliner.*

As a professor, Levine paid back the favor others had offered him in Iowa City. Just as Theodore Roethke practiced in Seattle, Levine opened his classes to poets who were not paying students. Administrators hassled him for it sometimes, but he kept doing it. Because he was teaching four or five courses a semester in the early days, this was a tremendous amount of student writing that he committed to reading. He also shared thoughtful correspondence with talented emerging poets around the country, offering direct and honest feedback on their work.

In 1965, Levine and his wife moved to Barcelona with their sons for the first of two yearlong stints abroad. The poet wanted to learn Spanish, and he was curious about whether he could create a life for himself outside the United States. The Spanish city reminded him a lot of Detroit: working-class and industrial. His experience there was not all that different from his Michigan days, either. He did not make much money, but he wrote a lot. He also spent a lot of hours with his children; he cherished that time with them for the rest of his life.

After returning to California, Levine had a strange dream where a man he worked with in Detroit called him on the telephone. He desperately wanted Levine to invite him to come to Fresno for a visit, and Levine did not invite him. Then he hung up and was consumed with the sense that he had betrayed the man. While he realized this was just a dream, the feeling stayed with him. "It probably was a warning that I should welcome back into myself all those people that had meant so much to me, and write about them."

In the last days of Levine's life as a worker in Detroit, "my sense was that the thing that's going to stop me from being a poet is the fact that I'm doing this crummy work," he said. "I mean, there are guys at Princeton and Yale and Harvard, and they're just sitting there writing their poems." But it turned out that the years he spent as a worker became the poetic material

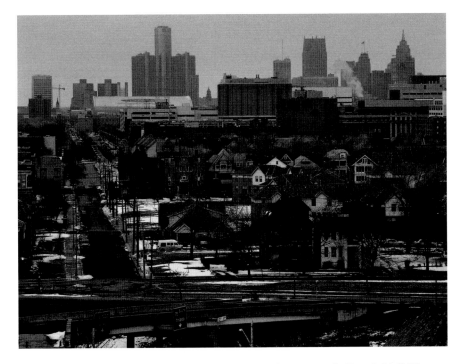

View over Midtown, Detroit, looking toward the downtown skyline. I-94/I-75 sweeps by the foreground. February 2007. *Geoff George.*

that he would depend on for the next sixty years. When Levine published *Not This Pig* in 1968, it was the first time he trusted his own life experience enough to put Detroit at the forefront.

Levine taught in Fresno until 1992, when he retired. He spent the next part of his life teaching at both Cal State classrooms and schools around the country, switching off semesters at places like New York University, Columbia University, the University of Houston and the University of North Carolina at Wilmington. Meanwhile, Levine and his wife divided their time between Fresno and Brooklyn.

"We had a good time," Franny told me. "We traveled a lot. We had a terrific life, we really did." Their three sons—Mark, John and Theodore—eventually gave them five grandchildren and a great-granddaughter.

Levine had not lived in Michigan for more than half a century; the last time he lived in Detroit, the city hummed with nearly two million residents. And yet, Levine continued to be associated with Detroit because he dedicated his poetic life to detailing what he remembered. His poems of Detroit are based on memory—a working-class childhood in a twentieth-

century empire—which gives them the ring of elegies. His work is peopled by autoworkers and immigrants, average men and women who do ordinary things like drive down the interstate all through the night. Beginning with his earliest work, he often tagged his poems with their time and place— "this was Michigan in 1928." They have a narrative drive fueled by Levine's experiments with fiction in his twenties. The title poem in *What Work Is* calls back to Levine's real-life experience of waiting outside two hours for a job at Ford's Highland Park factory. He had seen a newspaper ad saying that the plant was hiring. Prospective laborers should show up at eight o'clock in the morning to apply. Levine sidled in somewhere in the middle of the long line, but the factory did not end up taking applications until 10:00 a.m.

> *Forget you. This is about waiting,*
> *shifting from one foot to another.*
> *Feeling the light rain falling like mist*
> *into your hair, blurring your vision*
> *until you think you see your own brother*
> *ahead of you, maybe ten places.*
> *You rub your glasses with your fingers,*
> *and of course it's someone else's brother,*
> *narrower across the shoulders than*
> *yours but with the same sad slouch…*

Levine believed that the factory purposely had workers show up two hours before they took applications because it wanted to hire docile people who could wait quietly, standing on their feet, for hours at a time.

"There'll always be working people in my poems because I grew up with them, and I am a poet of memory," Levine said in 2001. His poetry is a testimony to a particular sort of mid-century urban life, steeped in memory and crowded with clear-eyed portraiture. "Winter Words," included in *A Walk with Thomas Jefferson* (1988), distills the essence of Levine's work:

> *Detroit, 1951,*
> *Friday night, after swing shift we drove*
> *the narrow, unmarked country roads searching*
> *for Lake Erie's Canadian shore.*
> *Later, wrapped in rough blankets, barefoot*
> *on a private shoal of ground stones*

we watched the stars vanish as the light
of the world rose slowly from the great
gray inland sea. Wet, shivering, raised
our beer cans to the long seasons
to come. We would never die.

Levine's writing also explores how the city experienced crisis. He had been away from Detroit for nearly fifteen years when the July 1967 insurrection happened, but he purposely visited it in the aftermath to see what had happened. And he wrote about it. He called *They Feed They Lion* (1972) a "celebration of anger." The title poem is a driving litany of images, one piled upon another, tracing the topography of emotion as it builds its own kind of logic. It becomes an incantation:

Out of burlap sacks, out of bearing butter,
Out of black bean and wet slate bread,
Out of the acids of rage, the candor of tar,
Out of creosote, gasoline, drive shafts, wooden doilies,
They Lion grew.

"The American experience is to return and discover one cannot even find the way," Levine wrote in 1994, "for the streets abruptly end, replaced by freeways, the houses have been removed for urban renewal that never takes place, and nothing remains."

Levine's career, especially in later years, was showered with honors. *Ashes: Poems New and Old* won the National Book Award and National Book Critics Circle Award in 1980. *What Work Is* also won the National Book Award, and it went on to sell tens of thousands of copies—extraordinarily rare for a collection of poems. Levine won another NBCC award for *7 Years from Somewhere*. In 1994, his book *The Simple Truth* won the Pulitzer Prize. While it was big news nationally, the honor was recorded with only a little story at the bottom of the front page of the *Fresno Bee* and two poem excerpts inside. Only two weeks earlier, the same paper had reported on the hiring of a new basketball coach at Cal State Fresno with a banner headline—"It's TARK TIME"—and no fewer than a dozen articles. In 2011, Levine was named the U.S. poet laureate at age eighty-three, making him one of the oldest laureates ever.

The big prizes transformed Levine's life. Not only did he sell a lot of books, but he was also in a position to charge a lot of money for his poetry readings. At the same time, he felt obliged to try to not let the honors inflate his ego—he

had seen former classmates fall apart after they were lauded, unable to write anything but faint mimicry of their earlier work. To keep focused, Levine stopped drinking to excess and stopped smoking dope, which he believed had negative impacts on his memory and his discipline. He stopped telling lies because he felt superstitious. "I have this feeling that I'm misusing language when I lie, and language is my medium—I can't betray it. If I start lying, my poems won't come to me."

Whatever the reason, the poems, it seemed, kept coming to him. When Levine published *A Mercy* in 2001, it was his eighteenth collection. He dedicated it to his mother, who had died the previous spring at age ninety-four. "I hope the book contains some of her zest for life, some of her belief in the power of beauty, some of her great humor," Levine said at the time in an interview with poet Edward Hirsch. "As a teacher you too must have known many young people who wanted to pursue poetry but were discouraged by their families. I'm one lucky guy to have had Esther Levine for my mother."

Levine's later poetry developed a longer line and a slower pace. They linger more over detail and have more soft sentiment in them. Until the day that Levine died, at home, at age eighty-seven, on Valentine's Day 2015, his wife, Franny, still looked over his drafts. Even within his poems, he laments the failure of language to capture the full spirit of a place or its people, especially in a culture full of mindless chatter that numbs us.

"I just wanted to tell the stories of people whom I found extraordinary and dear," Levine said. "I saw them pass from the world, and nobody said a goddamn word about them, so I said, 'Well, this is a subject matter that is mine and mine alone.'"

Epilogue
How to Build a Literary Culture

Joyce Carol Oates told me that there is nothing that any city can do to ensure that its talented writers thrive. "Writers and artists will make their own way," she said. "Affluence is not necessarily the best environment for an artist. My husband and I were certainly not affluent when we first moved to Detroit as a young married couple. It is usually a good idea to have a substantial job while one writes—teaching, in my case. Only rarely do writers and artists make a living with their creative work."

In other words, no particular city or circumstance creates a writer; writers create themselves. True enough. But at the same time, *readers* are created in communities with a literary culture. And when there are on-the-ground opportunities for writers to connect with booklovers and for writers to connect with one another, creative cross-fertilization inspires and challenges artists. It makes their writing better.

Traverse City and Detroit can boast of two distinct literary cultures in two radically different settings. Traverse City is a bayside town of fifteen thousand people, the largest city in the twenty-one counties of Northern Michigan. The community has a lively arts scene that includes a major film festival, the celebrated City Opera House and the National Writers Series (NWS). Billed as a "year-round book festival," NWS spotlights authors, journalists and other storytellers in monthly one-on-one conversations that are successful enough to make Northern Michigan a prime venue for any author's book tour. It has been known to draw up to seven hundred people to events, charging twenty to twenty-five dollars at the door (with discounts

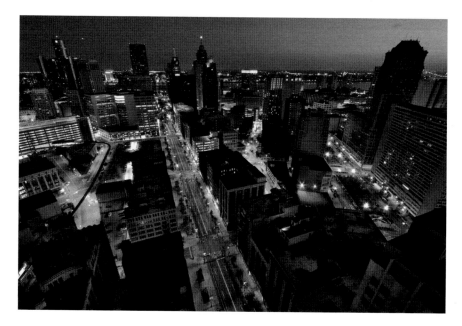

Dusk over Detroit, Michigan. September 2009. *Geoff George.*

for educators and students). Nikki Giovanni, Temple Grandin, Colum McCann, Bonnie Jo Campbell, Jack Driscoll, Jeffrey Eugenides, Mary Karr and Anchee Min are among the top-tier writers brought to the stage. Founded in 2009 by Doug Stanton, a bestselling author himself, NWS is dedicated to enlivening the connection between readers and writers—even as some publishers have left the traditional book tour for dead.

Stanton was himself on a book tour in 2009 when he noticed "dramatic changes" since his previous tour. "I asked around the country [about what] was working at book events," he told me in a 2012 interview for *Publishing Perspectives*. "I heard that cookbook authors have the greatest success turning out audiences, and it's because they're doing something other than reading and giving lectures." Stanton also learned that it costs about $2,500 to send authors to each city—which he understood to mean that each city needs to serve authors well on what can be a long and lonely trip, both in terms of giving them a great turnout and amplifying their visit with media coverage.

Stanton got in the game: he returned to Traverse City, set up at the kitchen table and drew a logo. The NWS angle was to put on stage a great interview with the author, one that is "really more like a conversation, a mind meld," Stanton said. "When you engage the author as a human being, it really invites the audience to lean in."

They did lean in for the first event featuring Elmore Leonard—and they kept coming back. Audiences responded to what Stanton calls the "dinner party aspect" of the interviews. Authors are advised that they should not feel like they need to cover everything while they are on stage. "We work really hard to create a moment on stage where authors are revealed."

As successful as the live events are, NWS also records the interviews and then broadcasts them on cable television and public radio. Every NWS author does several pre-event radio appearances, is covered in print media and is discussed on social media forums. "That comes free," Stanton said. "As an author, I know how important it is. Authors appreciate us going the extra mile. They know that if no one hears you, the reality is that you stay surrounded in silence."

This comes, of course, as literary media has been painfully downsized. Book reviewers have been fired, and radio producers have been axed—or are doing three jobs. Stanton noticed all this from his own book tour. "I don't get that at all," Stanton said. "More people are buying books than ever. They're reading more than ever. People are hungry for this stuff."

"Socketed away, in a rural, out-of-the-way place," NWS curates a vivid literary culture that treats authors and readers well. That's how author Richard Ford put it when I spoke to him. As an NWS author, he said, "you get to feel useful in a way writers rarely get to feel useful. It humanizes writers to the reading public. And there's a very rich reading public in Traverse City, which shouldn't be surprising but is to many people."

Marlena Bittner, assistant publicity director at the publisher Little, Brown, sent David Sedaris to NWS ("he adored it"). She told me that NWS is revealing a market in Michigan that publishing companies have not connected to. "There's an entire market ignored. Readers aren't just in huge publishing cities," she said. "There are certain core markets we go to again and again, and we very rarely diverge from that." She said that her authors return regularly to certain bookstores where they consistently have good experiences. But Bittner is reminded of readers living in areas without a leading bookseller—including her own hometown in Pennsylvania, which lost its main bookshop when Borders closed. "But there are still readers there, intelligent people who want to engage with writers," she said.

Not only is NWS offering a new possibility for readers, writers and publishers to intersect, but it is doing so in a big way. "In some ways, publishers are thinking in the middle, or smaller, because we hear all this bad news about nobody reading books anymore," Bittner said. She is just pleased that NWS is offering happy news in what otherwise appears to be a bleak

time for the book industry. "It feels like a joyous movement [in Traverse City]," she said. "This isn't some perfunctory event. It's exciting."

Reminded of his time as a student at Michigan's Interlochen Arts Academy, and of the significance he felt in people "taking me far more seriously as a writer than I deserved to be taken," Stanton expanded his literary vision into the public schools. After expenses, NWS puts profits into a scholarship fund to connect students with the literary life through Front Street Writers. It is a program that offers two recent MFA grads $10,000 a year, plus housing, to come to Traverse City and teach a full-year creative writing class for public school teenagers. Enrollment is free, and Front Street students publish their own literary journal. NWS authors teach guest classes. Besides the writing practice, Stanton wants literary authors to "seem real and normal in our public school systems." It is a populist move that moves him to the language of social change. "It's not enough for the 1 percent of authors to be taking tours," he said. "If that happens, we all retreat into the corner. Books should be in every hand on Main Street. Books should occupy public space. It's time for us to re-occupy readers' attention."

Write A House renovates vacant Detroit homes and gives them away to writers. Organic Weapon Arts publishes fine chapbooks and poetry films. The InsideOut Literary Arts Project places writers in residence in Detroit schools. All together, there is no use trying to measure the diverse literary culture in Detroit. There are too many good stories to tell.

Here is one.

Ken and Ann Mikolowski founded the Alternative Press (TAP) in their Cass Corridor home at 4339 Avery Street in 1969. They were inspired by their friends down the road, artists and musicians who created the Detroit Artists Workshop, an avant-garde collective that staged free Sunday poetry events. Musicians like Sun Ra and Archie Shep sometimes performed at the poetry open houses after playing at jazz clubs the night before, and several hundred guests might come by to listen. The workshop also printed, with its own press, lefty magazines, books, pamphlets and the *Warren-Forest Sun* newspaper. It gave away poetry in an effort called "Free Poems Among Friends." The collective eventually sold the Mikolowskis the letterpress—built in 1904, weighing half a ton—that the couple would use for the next thirty years.

Number 4339 Avery Street in Detroit, the first home of the Alternative Press. October 2014. *Anna Clark.*

Ann was an artist. Ken was a poet. With the Alternative Press, they were able to collaborate. It took some muddling as they taught themselves how to work the fussy antique machine, but the result was breathtaking. Rather than traditional books, work published by TAP was unbound and hand-printed art. Ann and Ken experimented with everyday materials, from bookmarks to postcards to tea bags. At first, they gave their work away as free broadsides. Later, they printed poetry that was beautifully packaged as mail art and posted in packets every few months to subscribers. The idea was to surprise recipients—to charm them visually and entice them to read a poem. The Mikolowskis were creating a literary medium that was joyful, inclusive, surprising and unpretentious. By publishing poetry in fragments—literally, in mailed packets of material, and subtly, by publishing early drafts from renowned poets—TAP also demystified the literary process.

Doing the work themselves offered more creative freedom than Ken had, for example, when he edited the *Wayne Review*, the student literary journal at Wayne State University. His efforts to experiment with color and include all the Detroit poets he admired were met with a frown from poet W.D. Snodgrass, the faculty supervisor. At TAP, it was no trouble to

Ken and Ann Mikolowski sort type at the Alternative Press, housed in the basement of their home on Avery Street. Circa 1969. *Courtesy of Ken Mikolowski.*

experiment with type, texture, color, size or paper weight. In fact, it was fun. Even when it came to long hours of setting cold type by hand.

TAP published Detroit poets—Chris Tysh, Jim Gustafson, Faye Kicknosway—alongside Beat and Black Mountain writers, including Anne Waldman, Charles Bukowski, Gary Snyder, Robert Creeley and Allen Ginsberg. "The attention given to each poem made it possible, were it a good poem, to see it as an isolated mental event—having a small perfectly defined place in a world gone mad with monster breakable petrochemical machines," wrote Ginsberg about the press.

"We had big egos," Mikolowski, my former poetry teacher, told me. "We knew we were just as good as anybody in New York or San Francisco."

National writers and artists were often guests of the Mikolowskis. It was Ginsberg who told his peers that they should be sure to look up "the cute couple in Detroit." The Avery Street house became a nerve center for artists. At a time when thousands of people were streaming out of Detroit, the Mikolowskis were part of a creative community that was pointedly living in the heart of the city. In fact, the reason the couple was able to buy their home in the first place—it had thirteen rooms and oak paneling, and they were only twenty-five years old—was because the price was slashed in half in the wake of the July 1967 riot.

"Everybody was influencing everybody else," Mikolowski said. "That was really important to me. And it really was work, too."

Alongside TAP, Ken and Ann created their individual art. Ken published a couple books of poetry and read poems during intermission at the Grande Ballroom when the MC5 or Iggy Pop performed. Ann created a fascinating series of miniature portraits of poets and artists, made with only a few strands of a paintbrush.

TAP lived on Avery for six years before moving to Grindstone City, a tiny town at the tip of Michigan's thumb. "It was the time when all the hippies were going to the country," Mikolowski said. Ken and Ann lived in a building that once housed a general store—light streamed through the large windows—and they learned to plant things in a huge organic garden.

Ken and Ann Mikolowski review broadsides printed by the Alternative Press. Circa 1969. *Courtesy of Ken Mikolowski.*

EPILOGUE

Their Detroit friends often visited, and Ann created gorgeous oil paintings of Lake Huron. Ken got a part-time job teaching poetry at the University of Michigan in Ann Arbor. While that required an enormous commute, it was also all the income he and his wife needed to live on for fifteen years.

In time, the press moved with the couple to Ann Arbor, and it continued there until Ann's death from breast cancer in 1999 at age fifty-nine. Struck still by emotion, it was seven long years before Ken felt able to finish printing and mailing the final issue of TAP—a packet including writings by Ginsberg, Lee Ann Brown and Sadiq Bey. But he did it. And by posting that final packet to old-time subscribers, he put the exclamation point on the worth of a life spent making art and sharing it.

Selected Sources

Allen, Eddie B. "Detroit-sploi-tation." *Metro Times,* March 24, 2004. http://www.metrotimes.com/detroit/detroit-sploi-tation/Content?oid=2178205 (accessed January 11, 2015).

———. *The Life and Legacy of Donald Goines*. New York: St. Martin's Press, 2004.

Andrews, William L., Francis Smith Foster and Trudier Harris, eds. *The Concise Oxford Companion to African American Literature*. New York: Oxford University Press, 2001.

Arnow, Harriette Simpson, Sandra L. Ballard and Haeja K. Chung. *The Collected Short Stories of Harriette Simpson Arnow*. East Lansing: Michigan State University Press, 2005.

Arnow, Harriette Simpson. *The Dollmaker*. 1954. Reprint, New York: Avon Books, 1972.

———. *Hunter's Horn*. New York: MacMillan Company, 1949.

———. *The Weedkiller's Daughter*. 1970. Reprint, East Lansing: Michigan State University Press, 2012.

Baker, Carlos. *Ernest Hemingway: A Life Story*. New York: Charles Scribner's Sons, 1969.

Barron, James. "Up in Michigan." *New York Times,* November 24, 1985. http://www.nytimes.com/1985/11/24/travel/up-in-michigan.html (accessed January 13, 2015).

Belth, Alex. "Even Bank Robbers Decide What Tie to Wear: The Essence of Elmore Leonard." *Deadspin*, September 16, 2014. http://thestacks.deadspin.com/elmore-leonards-researcher-the-coolest-job-ever-1633095773 (accessed January 11, 2015).

Bissell, Tom. "The Last Lion." *Outside Magazine*, August 31, 2011. http://www.outsideonline.com/outdoor-adventure/celebrities/The-Last-Lion.html (accessed January 10, 2015).

Blum, Howard. "In Detroit, Poet Laureate's Work Is Never Done." *New York Times*, January 30, 1984. http://www.nytimes.com/1984/01/30/us/in-detroit-poet-laureate-s-work-is-never-done.html (accessed January 1, 2015).

Boyd, Melba Joyce. *Wrestling with the Muse: Dudley Randall and the Broadside Press*. New York: Columbia UP, 2004.

Campbell, Bonnie Jo. *American Salvage*. Detroit, MI: Wayne State UP, 2008.

———. *Once Upon a River*. New York: W.W. Norton, 2011.

Challen, Paul. *Get Dutch! A Biography of Elmore Leonard*. Toronto: ECW Press, 2000.

Charbonneau, Jean. "Donald Goines Superstar." *In Posse Review*, Winter 2006. http://webdelsol.com/InPosse/winter06/IPR_Charbonneau.htm (accessed January 12, 2015).

Conway, Mimi (interviewer), and Harriette Arnow (interviewee). *Interview with Harriette Arnow, April, 1976*. [Interview transcript]. Retrieved from Southern Oral History Program Collection website, http://docsouth.unc.edu/sohp/G-0006/G-0006.html.

Curtis, Christopher Paul. *Bud, Not Buddy*. New York: Scholastic, 1999.

———. *The Watsons Go to Birmingham, 1963*. 1995. Reprint, New York: Laurel Leaf, 2000.

Dennis, Jerry. "Jim Harrison: A Northern Michigan Literary Icon." *MyNorth*, September 2, 2014. http://mynorth.com/2014/09/jim-harrison-a-northern-michigan-literary-icon (accessed January 10, 2015).

Derricotte, Toi. *The Black Notebooks: An Interior Journey*. 1997. Reprint, New York: W.W. Norton, 1999.

Distinguished Contribution to American Letters 2012. http://www.nationalbook.org/amerletters_2012_leonard.html#.VLMbUqblJbU (accessed January 15, 2015).

Edwards, Elizabeth. "Hemingway in Northern Michigan." *MyNorth*, June 15, 2012. http://mynorth.com/2012/06/hemingway-in-northern-michigan (accessed January 13, 2015).

Eugenides, Jeffrey. *The Marriage Plot*. New York: Farrar, Straus and Giroux, 2011.

———. *Middlesex*. New York: Picador. 2002.

———. *The Virgin Suicides*. 1993. Reprint, New York: Picador, 2009.

Fassler, Joe. "'It Has to Come to You': Why Jim Harrison Writes Patiently." *Atlantic*, January 7, 2014. http://www.theatlantic.com/entertainment/archive/2014/01/it-has-to-come-to-you-why-jim-harrison-writes-patiently/282799 (accessed January 10, 2015).

Federspiel, Michael. "Up North with the Hemingways." *Michigan History Magazine*, September/October 2005. http://www.michiganhemingwaysociety.org/articlelinks/UpNorthFederspiel.htm (accessed January 13, 2015).

Fergus, John. "Jim Harrison, The Art of Fiction No. 104." *Paris Review*, Summer 1988. http://www.theparisreview.org/interviews/2511/the-art-of-fiction-no-104-jim-harrison (accessed January 10, 2015).

Flynn, John. "A Journey with Harriette Simpson Arnow." *Michigan Quarterly Review* 29, no. 2 (Spring 1990): 241–60. http://hdl.handle.net/2027/spo.act2080.0029.002:12.

Fussman, Cal. "Jim Harrison: What I've Learned." *Esquire*, July 29, 2014. http://www.esquire.com/authors-learned/jim-harrison-interview-0814 (accessed January 10, 2015).

———. "What I've Learned: Elmore Leonard." *Esquire*, March 31, 2005. http://www.esquire.com/authors-learned/elmore-leonard-what-ive-learned (accessed January 11, 2015).

Goines, Donald. *Black Gangster*. 1977. Reprint, New York: Holloway House Classics, 2008.

———. *Dopefiend*. 1971. Reprint, New York: Holloway House Classics, 2007.

———. *El Dorado Red*. 1974. Reprint, New York: Holloway House Classics, 2000.

———. *Never Die Alone*. 1988. Reprint, New York: Holloway House Classics, 2000.

———. *White Man's Justice, Black Man's Grief*. 1973. Reprint, New York: Holloway House Classics, 2008.

———. *Whoreson*. 1972. Reprint, New York: Holloway House Classics, 2007.

Goldstein, Bill. "Author Chat: Elmore Leonard and Martin Amis." *New York Times*, February 10, 1999. http://www.nytimes.com/books/99/02/07/specials/leonard-amis-transcript.html (accessed January 11, 2015).

Goldstein, Laurence, and Robert Chrisman, eds. *Robert Hayden: Essays on the Poetry*. 2001. Reprint, Ann Arbor: University of Michigan Press, 2013.

Goodman, Charlotte. "The Multi-Ethnic Community of Women in Harriette Arnow's *The Dollmaker*." *MELUS* 10, no. 4 (Winter 1983): 49–54. http://www.jstor.org/discover/10.2307/467012?sid=21105602814703&uid=4&uid=2&uid=3739256&uid=3739520.

Gourevitch, Philip, ed. *The Paris Review Interviews*. Vol. 3. New York: Picador, 2008.

Greaseley, Philip A., ed. *Dictionary of Midwestern Literature*. Vol. 1, *The Authors*. Bloomington: Indiana University Press, 2001.

SELECTED SOURCES

Harrison, Jim. *Farmer*. 1976. Reprint, New York: Dell, 1989.

———. "Jim Harrison: On Leaving Leelanau County." *MyNorth*, September 5, 2014. http://mynorth.com/2014/09/jim-harrison-on-leaving-leelanau-county/ (accessed January 10, 2015).

———. *Letters to Yesenin*. 1973. Reprint, Port Townsend, WA: Copper Canyon Press, 2007.

———. "My Upper Peninsula." *New York Times*, November 29, 2013. http://www.nytimes.com/2013/12/01/travel/my-upper-peninsula.html (accessed January 10, 2015).

———. *True North*. New York: Atlantic Monthly Press, 2004.

———. *The Woman Lit by Fireflies*. New York: Grove Press, 1990.

Hayden, Robert. *American Journal*. 1978. Reprint, New York: Liveright Publishing Corporation, 1982.

———. *Angle of Ascent: New and Selected Poems*. New York: Liveright Publishing Corporation, 1975.

———. *Collected Poems*. Edited by Frederick Glaysher. New York: Liveright, 2013.

———. *Words in the Mourning Time*. New York: October House Inc., 1970.

Hemingway, Ernest. *The Complete Short Stories*. 1987. Reprint, New York: Scribner, 1998.

———. *The Nick Adams Stories*. 1972. Reprint, New York: Scribner, 2003.

Hirsch, Edward. "The Unwritten Biography." Poets.org, 2001. http://www.poets.org/poetsorg/text/unwritten-biography-philip-levine-and-edward-hirsch-conversation (accessed January 15, 2015).

Jackman, Michael. "Lasting Impressions." *Metro Times*, November 15, 2006. http://www.metrotimes.com/detroit/lasting-impressions (accessed January 15, 2015).

Kasischke, Laura. *Eden Springs*. Detroit, MI: Wayne State UP, 2010.

Kennedy, X.J. "Joy, Griefs, and 'All Things Innocent, Hapless, Forsaken.'" *New York Times*, August 23, 1964. http://www.nytimes.com/books/98/08/30/specials/dickey-helmets.html (accessed January 11, 2015).

Kenyon, Jane. *Collected Poems*. Minneapolis, MN: Graywolf Press, 2005.

Kiley, Brendan. "Drunk Diver." *The Stranger*, March 1, 2007. http://www.thestranger.com/seattle/Content?oid=166026 (accessed January 11, 2015).

Kunitz, Stanley. "Theodore Roethke." *New York Review of Books*, October 17, 1963. http://www.nybooks.com/articles/archives/1963/oct/17/theodore-roethke (accessed January 11, 2015).

LaGanga, Maria L. "Fertile Ground for Poetry." *Los Angeles Times*. May 16, 1995. http://articles.latimes.com/1995-05-16/news/mn-2516_1_philip-levine (accessed January 15, 2015).

Leonard, Elmore. *City Primeval: High Noon in Detroit*. Reprint, New York: William Morrow, 2012.

———. *52 Pickup*. Reprint, New York: William Morrow, 2013.

———. *Swag*. Reprint, New York: William Morrow, 2012.

———. *Unknown Man, #89*. Reprint, New York: William Morrow, 2013.

Leonard, John. "The Guise of Dolls." *New York Magazine*, May 14, 1984.

Levine, Philip. *The Names of the Lost*. New York: MacMillan, 1976.

———. *News of the World*. New York: Alfred A. Knopf, 2009.

———. *One for the Rose*. New York: MacMillan, 1981.

———. *The Simple Truth*. New York: Knopf, 1996.

———. *So Ask: Essays, Conversations, and Interviews*. Ann Arbor: University of Michigan Press, 2002.

———. *What Work Is: Poems*. 1991. Reprint, New York: Alfred A. Knopf, 1992.

Macdonald, Jay. "Jim Harrison Learns His Money Lesson." Bankrate. com, June 22, 2004. http://www.bankrate.com/brm/news/investing/20040622a1.asp (accessed January 10, 2015).

Marmer, Jake. "Philip Levine, Fierce About Poetry." *Tablet*, April 16, 2012. http://tabletmag.com/jewish-arts-and-culture/books/96700/philip-levine (accessed January 15, 2015).

May, Jamaal. *Hum*. Farmington, ME: Alice James Books, 2013.

McGrath, Charles. "Pleasures of a Hard-Won Life." *New York Times*, January 25, 2007. http://www.nytimes.com/2007/01/25/books/25harr.html (accessed January 11, 2015).

Mikolowski, Ken. *Big Enigmas*. Detroit, MI: Past Tents Press, 1991.

Milazzo, Lee, ed. *Conversations with Joyce Carol Oates*. Jackson: University Press of Mississippi, 1989.

Morris, Bill. "A Poet Laureate from the Proletariat: An Appreciation of Philip Levine." *The Millions*, October 2, 2011. http://www.themillions.com/2011/10/a-poet-laureate-from-the-proletariat-an-appreciation-of-philip-levine.html (accessed January 15, 2015).

NPR Staff. "New Poet Laureate Philip Levine's 'Absolute Truth.'" NPR, August 14, 2011. http://www.npr.org/2011/08/14/139576125/new-poet-laureate-philip-levines-absolute-truth? (accessed January 15, 2015).

Oates, Joyce Carol. *Expensive People*. 1968. Reprint, New York: Fawcett Crest, 1970.

———. *High Crime Area: Tales of Darkness and Dread*. New York: Mysterious Press, 2014.

———. *Them*. 1969. Reprint, New York: Modern Library, 2006.

———. "To Invigorate Literary Mind, Move Literary Feet." *New York Times,* July 18, 1999. http://www.nytimes.com/library/books/071999oates-writing.html (accessed January 10, 2015).

———. "A Widow's Story." *New Yorker,* December 13, 2010. http://www.newyorker.com/magazine/2010/12/13/a-widows-story (accessed January 1, 2015).

Ogunnaike, Lola. "Credentials for Pulp Fiction: Pimp and Drug Addict." *New York Times,* March 25, 2004. http://www.nytimes.com/2004/03/25/movies/credentials-for-pulp-fiction-pimp-drug-addict-for-novelist-donald-goines-dead-30.html (accessed January 12, 2015).

Piehl, Beth Anne. "Windemere on Walloon." *HomeLife,* July/August 2009. http://www.miseasons.com/homelife/issues/julaug09/windemere.html (accessed January 13, 2015).

Porter, Gary. "Upper Peninsula Evokes Jim Harrison's Novels." *Milwaukee Journal-Sentinel,* September 14, 2012. http://www.jsonline.com/features/travel/upper-peninsula-evokes-jim-harrisons-novels-a76q6v0-169760496.html (accessed January 10, 2015).

Randall, Dudley. *After the Killing.* 1973. Reprint, Detroit, MI: Broadside Press, 1983.

———. *Cities Burning.* Detroit, MI: Broadside Press, 1968.

Rashid, Frank, ed. *Literary Map of Detroit.* Marygrove College. http://tinyurl.com/lxazopk (accessed 10 January 2015).

Roethke, Theodore. *On Poetry and Craft: Selected Prose of Theodore Roethke.* 1965. Reprint, Port Townsend, WA: Copper Canyon Press, 2001.

———. *The Waking: Poems, 1933–1953.* Garden City, NY: Doubleday, 1953.

Rose, Judy. "Michigan House Envy: A Look at Elmore Leonard's Home, Legacy." *Detroit Free Press,* September 15, 2013. http://archive.freep.com/article/20130915/BLOG46/309150019/Elmore-Leonard-House-envy (accessed January 11, 2015).

Rubin, Neal. "Elmore Leonard's Woodward Avenue." *Detroit News,* July 9, 2007. http://www.detroitnews.com/article/20070709/METRO/707090373 (accessed January 11, 2015).

Satterwhite, Emily. *Dear Appalachia: Readers, Identity, and Popular Fiction Since 1878.* Lexington: University Press of Kentucky, 2011.

Schott, Webster. "Farmer." *New York Times,* October 10, 1976. http://www.nytimes.com/books/98/11/08/specials/harrison-farmer.html (accessed January 10, 2015).

Seager, Allan. *The Glass House: The Life of Theodore Roethke.* 1968. Reprint, Ann Arbor: University of Michigan Press, 2005.

SELECTED SOURCES

Shaefer, Jim. "Funeral for Novelist Elmore Leonard Brings Laughter, Tears." *Detroit Free Press*, August 24, 2013. http://archive.freep.com/ article/20130824/NEWS/308240058/Elmore-Leonard-funeral-services (accessed January 12, 2015).

Shahar, Guy, and J.M. Spalding. "Philip Levine." *Cortland Review*, May 1999. http://www.cortlandreview.com/issue/7/levine7i.htm (accessed January 15, 2015).

Sharpe, Tony, ed. *W.H. Auden in Context*. New York: Cambridge University Press, 2013.

Showalter, Elaine. *A Jury of Her Peers: American Women Writers from Anne Bradstreet to Annie Proulx*. New York: Vintage, 2010.

Simpson, Mona. "Philip Levine, The Art of Poetry No. 39." *Paris Review*, Summer 1988. http://www.theparisreview.org/interviews/2512/the-art-of-poetry-no-39-philip-levine (accessed January 13, 2015).

Stephenson, Wen. "Poetry Pages." *Atlantic*, April 8, 1999. http://www. theatlantic.com/entertainment/archive/1999/04/poetry-pages/377558 (accessed January 15, 2015).

"Tour Hemingway's Michigan." *Pure Michigan*. http://www.michigan.org/ road-trips/tour-hemingway-s-michigan (accessed January 13, 2015).

Tucker, Neely. "Elmore Leonard Shoots His Way into the Library of America." *Washington Post*, August 28, 2014. http://www.washingtonpost. com/lifestyle/style/elmore-leonard-shoots-his-way-into-the-library-of-america/2014/08/28/cb35cf80-2d32-11e4-bb9b-997ae96fad33_story. html (accessed January 11, 2015).

Warn, Emily. "D.I.Y. Detroit." *Poetry Foundation*, April 20, 2011. http://www. poetryfoundation.org/article/241800 (accessed January 15, 2015).

Waterman, Nixon, ed. "Ben King's Verse." 1894. Reprint, Chicago: Forbes & Company, 1903. https://archive.org/stream/benkingsverse00king/ benkingsverse00king_djvu.txt.

Weinreb, Michael. "The Dickens of Detroit." *Grantland*, April 15, 2014. http://grantland.com/features/elmore-leonard-detroit-crime-novelist-dickens (accessed January 11, 2015).

Whitall, Susan. "Elmore Leonard Archives Go to South Carolina." *Detroit News*, October 15, 2014. http://www.detroitnews.com/story/entertainment/ books/2014/10/15/elmore-leonard-archives-university-south-carolina-detroit-crime-author/17299509 (accessed January 11, 2015).

Williamson, Jerry Wayne, and Edwin T. Arnold. *Interviewing Appalachia: The Appalachian Journal Interviews, 1978–1992*. Knoxville: University of Tennessee Press, 1994.

Worley, Sam. "Bumper Stickers, Bookmarks, Postcards." *Chicago Reader*, September 22, 2011. http://www.chicagoreader.com/chicago/letterpressed-poetry-foundation-mikolowski-alternative-press/Content?oid=4669180 (accessed January 15, 2015).

Yagoda, Ben. "Elmore Leonard's Rogue's Gallery." *New York Times*, December 30, 1984. http://www.nytimes.com/books/98/02/08/home/leonard-rogue.html (accessed January 11, 2015).

Yardley, Jonathan. "Also Extravagantly Free-Male." *New York Times*, December 12, 1971. http://www.nytimes.com/books/98/11/08/specials/harrison-wolf.html (accessed January 10, 2015).

Index

INDEX

INDEX

About the Author

Anna Clark is a journalist in Detroit. Her writing has appeared in the *New York Times*, the *New Republic*, *Politico*, the *Columbia Journalism Review*, the *Chicago Tribune*, the *Detroit Free Press* and other publications. She edited *A Detroit Anthology*, a 2015 Michigan Notable Book. She is the director of applications of Write A House and a writer-in-residence with the InsideOut Literary Arts Project. Anna was also a Fulbright fellow in Kenya, where she focused on creative writing. She graduated from the University of Michigan and from Warren Wilson College's MFA Program for Writers. She grew up in St. Joseph, Michigan, a little town she loves.